Vorspru

A
A
D

Art Architecture Design

HAMBURG

edited by Sabine von Wegen

teNeues

ART
ARCHITECTURE
DESIGN

A

A

D

Content

HAMBURG

I
N
T
R

Sabine von Wegen

Do you want to get to know Hamburg's art and culture scene better? Then you have made the right choice: In this guide you will learn what the second-largest harbor city in Europe has to offer besides the Reeperbahn. A flourishing trade thanks to shipping, paired with the international flair which foreigners brought to the city, have made Hamburg rich and, despite its small size, lent it a cosmopolitan atmosphere. Thanks to the citizens' wealth, it was possible to build the Kunsthalle in the middle of the 19th century in Hamburg, which did not have an electoral art collection like other cities.

Hamburg's architecture is also marked by trade and the economy. Here, it is not just the historic buildings that are interesting; what is more, the new buildings are works by well-known contemporary architects. Which ones precisely is set down for you here, and much more about the creative life, the art scene, and the design hotspots of the city.

O

Sie wollen Hamburgs Kunst- und Kulturszene näher kennenlernen? Dann haben Sie die richtige Wahl getroffen, denn in diesem Guide erfahren Sie, was die zweitgrößte Hafenstadt Europas außer der Reeperbahn noch zu bieten hat. Ein florierender Handel durch die Schifffahrt, gepaart mit dem internationalen Flair, das Fremde in die Stadt brachten, haben Hamburg wohlhabend gemacht und trotz der geringen Größe eine kosmopolitische Atmosphäre beschert. Durch den Wohlstand der Bürger war es Mitte des 19. Jahrhunderts möglich, in Hamburg, das nicht wie andere Städte eine kurfürstliche Herrschersammlung besaß, die Kunsthalle zu bauen.

Auch Hamburgs Architektur ist geprägt von Handel und Wirtschaft. Dabei sind nicht nur die historischen Gebäude interessant; hinter den Neubauten verstecken sich große Namen zeitgenössischer Architekten. Welche genau, das können Sie hier nachlesen, und noch vieles mehr über das kreative Leben, die Kunstszene und die Design-Hotspots der Stadt.

ART

Hamburg's art scene is very well established. The present Kunstverein (art association) is the oldest in Germany, and the largest German museum building is also located here: the Hamburger Kunst-halle. With the Deichtorhallen and the Falckenberg Collection, great value is placed on contemporary art with giant exhibition spaces. Bright German stars such as Jonathan Meese and Gerhard Richter had their first big exhibitions here in Hamburg, where people are open to the avant-garde—but with style, please, and in a large frame!

The galleries also love their affluent audience, and the off-scene is accordingly clear. Therefore it is even more interesting to seek out those locations, e.g. in St. Pauli, and to experience young gallerists who have developed a weakness for street art and urban art of all kinds. The occupation of the Gängeviertel by artists echoed positively across Hamburg; it prevented demolition and initiated cultural usage.

Hamburgs Kunstszene gilt als sehr etabliert. Der hiesige Kunstverein ist der älteste Deutschlands, und auch der größte deutsche Museumsbau befindet sich hier: die Hamburger Kunsthalle. Mit den Deichtorhallen und der Sammlung Falckenberg bringt man vor allem der Gegenwartskunst mit riesigen Ausstellungsflächen starke Wertschätzung entgegen. Deutsche Shootingstars wie Jonathan Meese oder Gerhard Richter hatten hier in Hamburg ihre ersten großen Ausstellungen, man ist offen für die Avantgarde – aber bitte mit Stil und in einem großen Rahmen!

Auch die Galerien lieben ihr zahlungskräftiges Publikum, und dementsprechend übersichtlich ist die Off-Szene. Umso interessanter ist es aber, diese Orte z. B. in St. Pauli aufzusuchen, und junge Galeristen zu erleben, die ein Faible für Streetart und urbane Kunst jeder Couleur entwickelt haben. Positives Echo in ganz Hamburg rief die Besetzung des Gängeviertels durch Künstler hervor, wodurch der Abriss verhindert und eine kulturelle Nutzung angestoßen wurde.

BUCERIUS KUNST FORUM

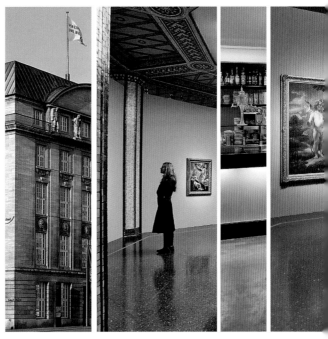

BUCERIUS KUNST FORUM

Rathausmarkt 2 // Altstadt
Tel.: +49 (0)40 3 60 99 60
www.buceriuskunstforum.de

Fri–Wed 11 am to 7 pm
Thu 11 am to 9 pm
S1, S3, U1, U2 Jungfernstieg
U3 Rathaus

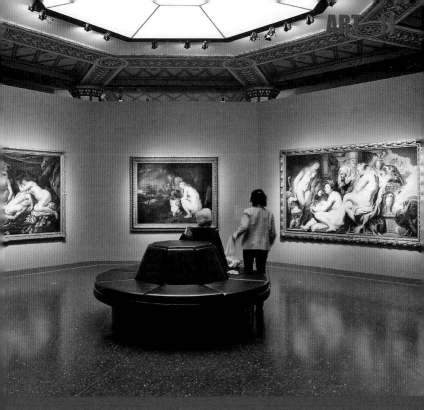

Today, the mosaic-decorated octagon of the former Reichsbank building no longer houses large sums of money, but rather big names in the art world. In four changing exhibitions each year, which are organized by international curators, significant works of various epochs are on display, from Sandro Botticelli to William Turner to Gerhard Richter.

Das mosaikverzierte Oktogon des ehemaligen Reichsbankgebäudes beherbergt heute keine großen Geldsummen mehr, dafür aber große Namen der Kunst. In vier wechselnden Ausstellungen jährlich, die in Zusammenarbeit mit internationalen Kuratoren erarbeitet werden, sind bedeutende Werke verschiedener Epochen zu sehen: von Sandro Botticelli über William Turner bis hin zu Gerhard Richter.

A

Erected from 1911 to 1914 as market halls, these steel and glass buildings bear rare witness to an industrial architecture that was in transition from art nouveau to the modern forms of expression that characterize the 20th century. In 1998, they were dedicated as exhibition space for contemporary art, consisting of the hall for contemporary art (with approximately 41,000 sq. ft. of exhibition space), the photography building designed largely by Professor F. C. Gundlach, and the Falckenberg Collection.

Von 1911 bis 1914 als Markthallen errichtet, legen die Stahl-Glas-Bauten seltenes Zeugnis einer Industriearchitektur ab, die sich im Übergang von Jugendstil zu den modernen Ausdrucksformen des 20. Jahrhunderts befand. 1998 wurden sie als Ausstellungshaus für zeitgenössische Kunst eingeweiht und bestehen heute aus der Halle für aktuelle Kunst (mit rund 3 800 m² Ausstellungsfläche), dem maßgeblich von Prof. F. C. Gundlach konzipierten Haus der Photographie und der Sammlung Falckenberg.

DEICHTORHALLEN HAMBURG

Deichtorstraße 1-2 // Altstadt
Tel.: +49 (0)40 32 10 30
www.deichtorhallen.de

Tue–Sun 11 am to 6 pm
every 1st Thu 11 am to 9 pm
S1, S2, S3, S11, S21, S31 Hauptbahnhof
U1 Steinstraße, Bus 112 U Steinstraße

Evelyn Drewes combs through art exhibitions, studios, and academies, looking for young and talented artists to present in her gallery at the historical Sprinkenhof. Her main interest is in concrete subjects. Furthermore, she puts a strong emphasis on helping her protégés through their first years in the often very demanding art business. This makes her gallery a great destination for ambitious art lovers who want to get an impression of new and unspent approaches.

Evelyn Drewes geht auf Kunstmessen, in Künstlerateliers und an Hochschulen auf die Suche nach jungen Kunsttalenten, und stellt sie in ihrer Galerie im historischen Sprinkenhof aus. Dabei interessieren sie vor allem gegenständliche Sujets. Der Galeristin ist es ein Anliegen, ihren Schützlingen in den ersten Jahren Starthilfe im harten Kunstgeschäft zu geben. Für ambitionierte Kunstliebhaber bietet die Galerie Gelegenheit, neue, unverbrauchte Positionen in Augenschein zu nehmen.

GALERIE POPARTPIRAT

Springeltwiete 2 // Altstadt
Tel.: +49 (0)151 11 53 62 22
www.popartpirat.de

Wed–Sat 2.30 pm to 6 pm
U1 Steinstraße

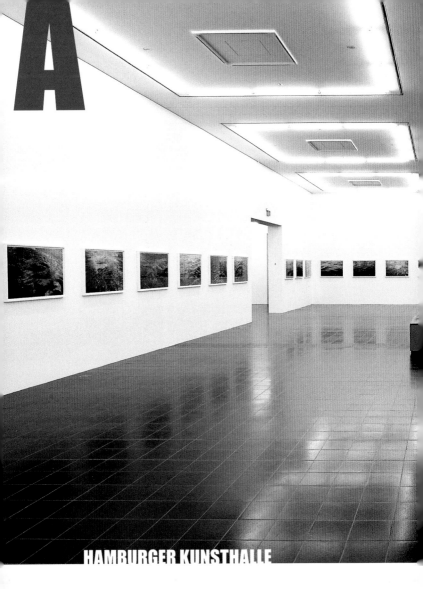

A

HAMBURGER KUNSTHALLE

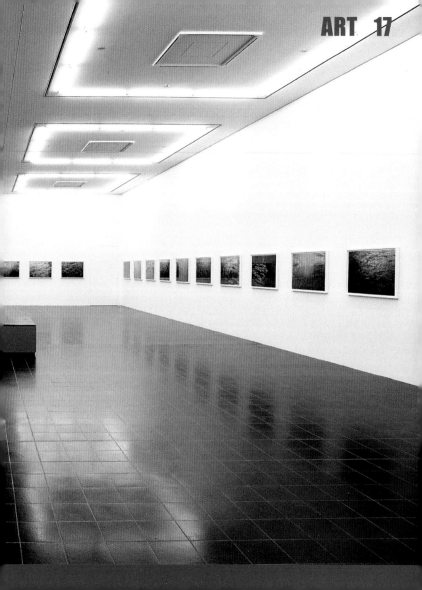

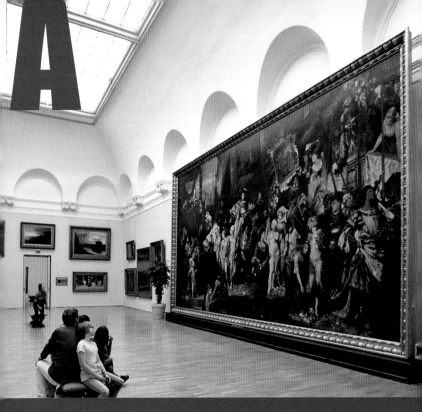

The huge museum building features more than 700 years of art under one roof in three connected buildings. A tour of this collection founded by citizens of Hamburg is like a trip through art history. Starting with the oldest work in the museum—an altar painting by Master Bertram from the 15th century—visitors stroll past works by Caspar David Friedrich, Pablo Picasso, Andy Warhol, Neo Rauch, and many, many more.

Das riesige Museumsgebäude versammelt in drei zusammenhängenden Häusern über 700 Jahre Kunst unter einem Dach. Ein Rundgang durch die von Hamburger Bürgern gegründete Sammlung kommt einer Zeitreise durch die Kunstgeschichte gleich. Angefangen beim ältesten Kunstwerk des Hauses, einem Altargemälde von Meister Bertram aus dem 15. Jahrhundert, flaniert der Besucher vorbei an Werken von Caspar David Friedrich, Pablo Picasso, Andy Warhol, Neo Rauch und vielen, vielen mehr.

HAMBURGER KUNSTHALLE

Glockengießerwall // Altstadt
Tel.: +49 (0)40 4 28 13 12 00
www.hamburger-kunsthalle.de

Tue–Sun 10 am to 6 pm
Thu 10 am to 9 pm
S1, S2, S3, S11, S21, S31, U1, U2, U3 Hauptbahnhof
Bus 112 Ferdinandstor

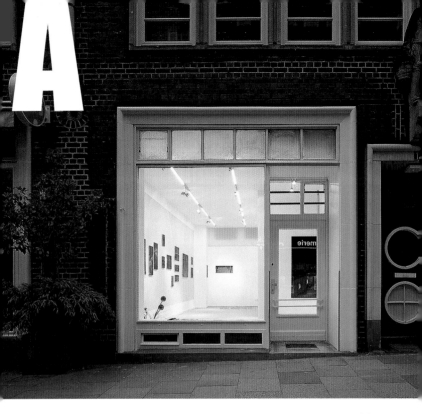

Sandra Kramer is especially interested in contemporary painting. Her gallery, which she opened in 2010, is in the historic rooms of the Altstädter Hof in the Kontorhausviertel, which was completed in 1937. She displays young and already-established artists; some works like those of Menno Fahl, Anna Gestering and Henrik Hold are a permanent exhibit. This gallery owner also offers advice to art collectors with respect to establishing and maintaining their collections

Sandra Kramer interessiert sich besonders für zeitgenössische Malerei. Ihre Galerie, die sie 2010 eröffnete, befindet sich in den historischen Räumlichkeiten des 1937 fertiggestellten Altstädter Hofes im Kontorhausviertel. Sie zeigt junge und bereits etablierte Künstler, einige Arbeiten wie die von Menno Fahl, Anna Gestering oder Henrik Hold sind dauerhaft zu sehen. Die Galeristin bietet zudem beratende Unterstützung für Kunstsammler bei Sammlungsaufbau und Sammlungspflege an.

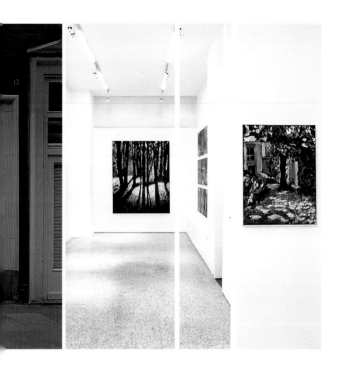

KRAMER FINE ART

Altstädter Straße 13 // Altstadt
Tel.: +49 (0)40 31 81 01 54
www.kramer-fine-art.de

Tue–Fri noon to 6.30 pm, Sat noon to 3 pm
and on appointment
S1, S2, S3, S11, S21, S31 Hauptbahnhof
U1 Steinstraße, U3 Mönckebergstraße

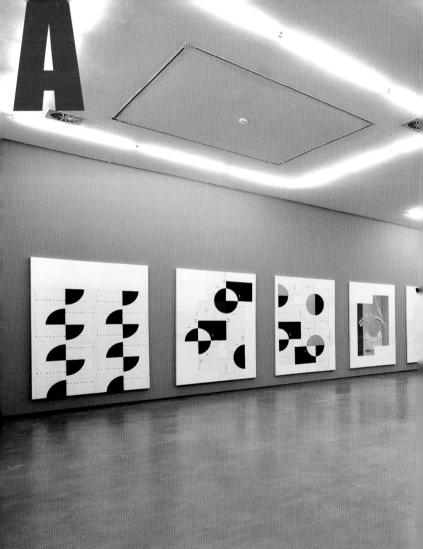

A

KUNSTVEREIN HAMBURG

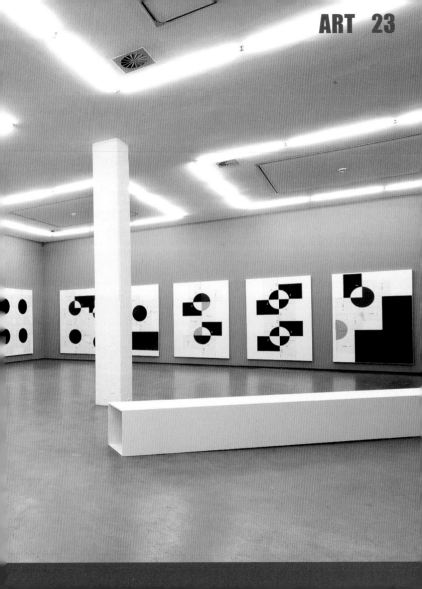

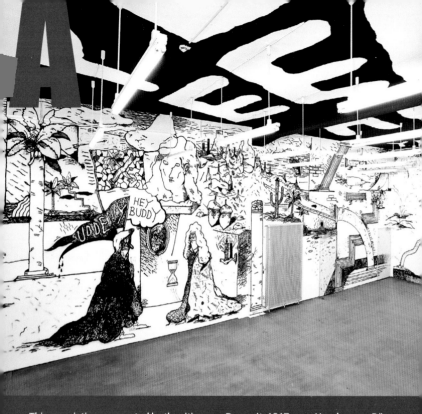

This association, supported by the citizens of Hamburg since 1817, is still devoted, as it always has been, to the presentation of contemporary art. The works of Caspar David Friedrich, Arnold Böcklin, and Francis Bacon were shown here in early solo exhibitions. Shows in the former market hall, between the Deichtorhallen and the Kunsthalle, react to current trends and socially-relevant topics, which are taken up in the works of both young and established artists.

Der seit 1817 von Hamburger Bürgern getragene Verein widmet sich damals wie heute der Präsentation zeitgenössischer Positionen. Schon Caspar David Friedrich, Arnold Böcklin oder Francis Bacon wurden hier in frühen Einzelausstellungen vorgestellt. Wechselnde Schauen in der ehemaligen Markthalle, zwischen Deichtorhallen und Kunsthalle, reagieren auf aktuelle Tendenzen und gesellschaftlich relevante Themen, die in den Arbeiten junger, aber auch etablierter Künstler aufgegriffen sind.

KUNSTVEREIN HAMBURG

Klosterwall 23 // Altstadt
Tel.: +49 (0)40 32 21 57
www.kunstverein.de

Tue–Sun noon to 6 pm
S1, S2, S3, S11, S21, S31 Hauptbahnhof
U1 Steinstraße

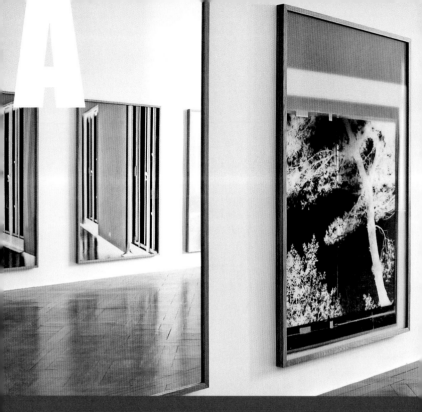

A

The focus of this renowned gallery is on contemporary art, whereby the media photography and video are also taken into consideration. Immediately after its opening in 1977, the gallery showed Joseph Beuys, Cy Twombly and Lucio Fontana. In addition to single shows, classic and the latest items are also shown in thematic exhibitions. The glass fronts of the new parts of the building added in 2010 create an exciting contrast to the original structure of the villa.

Der Fokus der renommierten Galerie liegt auf zeitgenössischer Kunst, wobei auch die Medien Fotografie und Video berücksichtigt sind. Unmittelbar nach der Eröffnung 1977 zeigte man hier bereits Joseph Beuys, Cy Twombly und Lucio Fontana. Neben Single-Shows werden heute in thematischen Ausstellungen auch klassische und jüngste Positionen gegenübergestellt. Die Glasfronten der neuen, 2010 hinzugefügten Gebäudeteile schaffen einen reizvollen Kontrast zur originalen Bausubstanz der Villa.

GALERIE VERA MUNRO

Heilwigstraße 64 // Eppendorf
Tel.: +49 (0)40 47 47 46
www.veramunro.de

Tue–Fri 9 am to 6 pm
Sat 11 am to 2 pm
U1, U3 Kellinghusenstraße

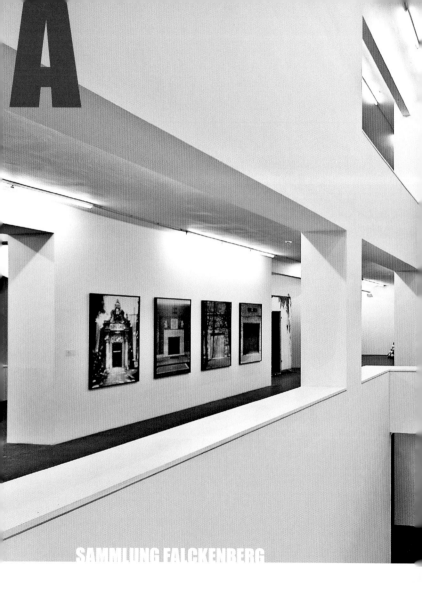

A

SAMMLUNG FALCKENBERG

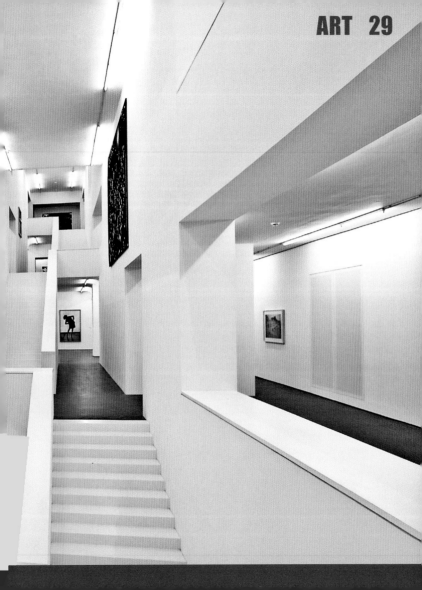

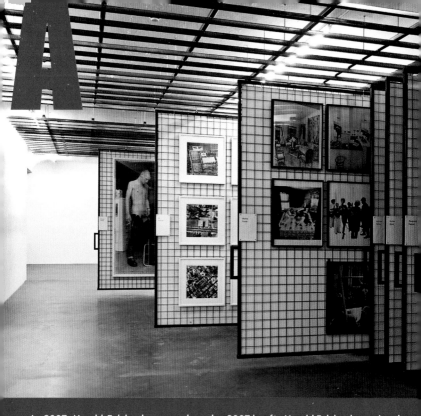

In 2007, Harald Falckenberg purchased one of the Phoenix halls in order to create exhibition space for approximately 2,000 contemporary works of art. The focus of the collection is American and German works of the last 30 years that project social caricatures with irony, cynicism and in the context of the counterculture. The works of Sigmar Polke, John Baldessari, and Jonathan Meese seem like painted monuments on the white walls of the hall, which are lit by neon lights.

2007 kaufte Harald Falckenberg eine der Phoenix-Hallen, um einen Ausstellungs-raum für rund 2 000 zeitgenössische Kunstwerke zu schaffen. Der Fokus der Sammlung liegt auf amerikanischen und deutschen Arbeiten der letzten 30 Jahre, die mit Ironie, Zynismus und im Kontext der Counterculture gesellschaftliche Zerr-bilder entwerfen. Die Werke von Sigmar Polke, John Baldessari oder Jonathan Meese wirken wie gemalte Monumente an den weißen, von Neonlicht bestrahlten Wänden der Halle.

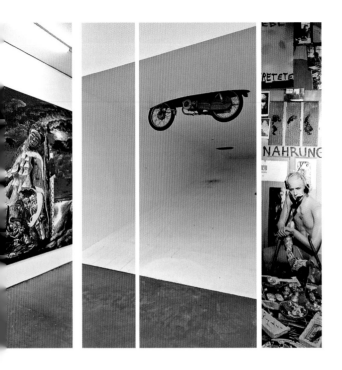

SAMMLUNG FALCKENBERG

Wilstorfer Straße 71, Tor 2 // Harburg
Tel.: +49 (0)40 32 50 67 62
www.sammlung-falckenberg.de

guided tours only (registration via website)
Wed–Thu 6 pm, Fri 5 pm, Sat–Sun 11 am and 3 pm
S3, S31 Harburg

HARALD
FALCK

ENBERG

As the Managing Director of Elaflex, a manufacturer of gas station accessories, Falckenberg benefited from the downturn in the art market in 1994, purchasing his first work of art; at the time, nobody suspected that this would become the cornerstone of one of the most significant private collections in Germany. Initially, Falckenberg's interest was in familiar names such as Warhol and Wesselmann. A few years later, however, he recognized the contemporary relevance of the young generation of artists. Since then, the Hamburg entrepreneur has only been interested in art which shocks and disturbs. In his selection, he is unerring; he was, for example, the first collector of Martin Kippenberger, Jonathan Meese, and Richard Prince—then unknown artists whose works increased rapidly in price. Thanks to his focus on young, critical contemporary art for exhibition, Harald Falckenberg's collection fills a gap in the Hamburg museum landscape.

Als der Geschäftsführer der Firma Elaflex, Hersteller für Tankstellenzubehör, sich 1994 den Tiefstand des Kunstmarktes zunutze machte und sein erstes Kunstwerk kaufte, ahnte niemand, dass dies der Grundstein für eine der bedeutendsten Privatsammlungen Deutschlands sein würde. Zunächst galt das Interesse Falckenbergs den bekannten Namen wie Warhol oder Wesselmann, bis er nach einigen Jahren die Relevanz der jungen Künstlergeneration für die Gegenwart erkannte. Der Hamburger Unternehmer interessiert sich seitdem nur noch für Kunst, die schockt und verstört. In seiner Auswahl ist er dabei durchaus treffsicher, er war beispielsweise einer der ersten Sammler von Martin Kippenberger, Jonathan Meese und Richard Prince – damals unbekannte Künstler, deren Werke sehr bald rapide im Preis stiegen. Durch die stringente Konzentration auf junge, kritische Gegenwartskunst in dieser musealen Dimension schließt Harald Falckenberg mit seiner Sammlung eine Lücke in der Hamburger Museumslandschaft.

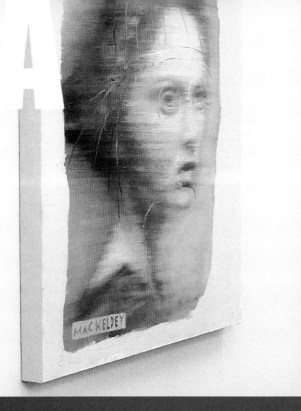

MAC KELDEY

Why did this gallery name itself after a space mission? Gallery owner Josef Schewe, who has also achieved success as a cartoonist and brand designer, does not want to be limited by genre boundaries, so the gallery's name conveys the symbolically endless nature of the art universe. Commercial work is also entitled to artistic recognition here, so apollo9 shows changing exhibitions of advertising, illustration, and design contract work as well as paintings, photographs, and sculptures.

Warum sich die Galerie nach einer Raumfahrtmission benannt hat? Galerist Josef Schewe, der auch als Cartoonist und Branddesigner erfolgreich ist, will sich nicht durch Genregrenzen einschränken lassen und symbolisch die Unendlichkeit des Kunstuniversums erkunden. Bei ihm haben auch kommerzielle Arbeiten ein Anrecht auf künstlerische Anerkennung, und so zeigt apollo9 in wechselnden Ausstellungen neben Gemälden, Fotografien oder Skulpturen auch Auftragsarbeiten aus Werbung, Illustration und Design.

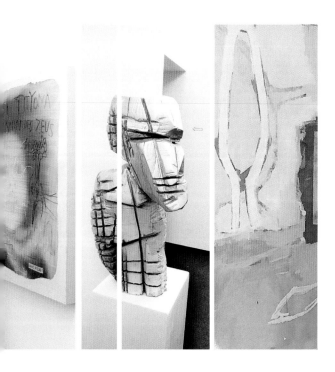

APOLLO9

Isestraße 89 // Harvestehude
Tel.: +49 (0)40 65 79 71 10
www.apolloneun.de

Tue–Fri noon to 6 pm, Sat noon to 4 pm
and on appointment
U1 Klosterstern
U3 Eppendorfer Baum

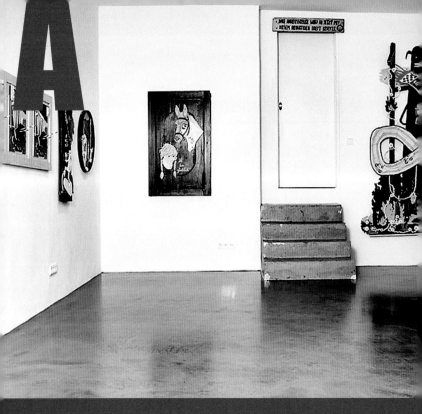

At Feinkunst Krüger, where exhibitions have been staged since 1998, the focus is on young Hamburg artists. The fact that gallery owner Ralf Krüger has a nose for the right selection is indicated by artists such as Till Gerhard and Henning Kles, whose works are now shown internationally. Another focal point is the presentation of low-brow and rock art works—art that arises in the environment of the American subculture.

Bei Feinkunst Krüger konzentriert man sich innerhalb des seit 1998 laufenden Ausstellungsbetriebs auf den Hamburger Kunstnachwuchs. Dass Galerist Ralf Krüger dabei ein Händchen für die richtige Auswahl hat, zeigt sich an Künstlern wie Till Gerhard oder Henning Kles, deren Werke inzwischen auch international gezeigt werden. Ein weiterer Schwerpunkt liegt auf der Präsentation von Lowbrow- und Rock-Art-Arbeiten – Kunst, die im Umfeld der amerikanischen Subkultur entsteht.

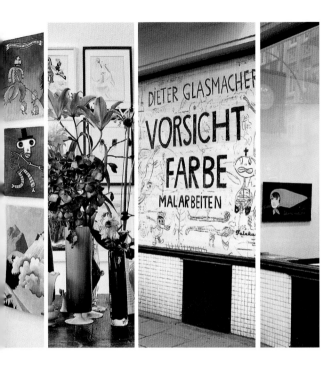

FEINKUNST KRÜGER

Ditmar-Koel-Straße 22 // Neustadt
Tel.: +49 (0)40 31 79 21 58
www.feinkunst-krueger.de

Tue, Fri noon to 7 pm
Sat noon to 6 pm
and on appointment
S1, S2, S3, U3 Landungsbrücken

Jörg Heikhaus, who has experience as an artist, photographer, agency founder, and CEO of a consulting company, regards himself and his gallery as a link between young, urban art and the commercial art market. With a portfolio of select names, he presents work that breaks aesthetic and social paradigms, and he also offers advice about art purchases. To visit the showroom, it is best to make an appointment by telephone.

Jörg Heikhaus, der selbst als Künstler, Fotograf, Agenturgründer und Chef eines Beratungsunternehmens Erfahrungen gesammelt hat, versteht sich mit seiner Galerie als Vermittler zwischen junger, urbaner Kunst und dem kommerziellen Kunstmarkt. Mit einem Portfolio ausgewählter Namen präsentiert er Arbeiten, die ästhetische und gesellschaftliche Paradigmen aufbrechen, und bietet zudem Beratung im Kunstkauf an. Für die Besichtigung des Showrooms sollte man telefonisch einen Termin vereinbaren.

HELIUMCOWBOY ARTSPACE

Bäckerbreitergang 75 // Neustadt
Tel.: +49 (0)40 48 40 88 60
www.heliumcowboy.com

on appointment
S1, S2, S3 Stadthausbrücke
U2 Gänsemarkt

The idea behind the self-proclaimed Editionsgalerie Lumas is to make contemporary works of photography available at affordable prices to young collectors and art enthusiasts with a tight budget. More than 1,400 pieces by renowned artists and newcomers are obtainable as autographed originals in limited edition. The gallery is only a short walk from the historic district of the city and draws by virtue of its changing exhibitions and events art admirers from all over Hamburg.

Die Idee der Editionsgalerie Lumas ist es, zeitgenössische Fotografie zu erschwinglichen Preisen für jüngere Sammler und Kunstbegeisterte mit begrenztem Budget zugänglich zu machen. Mehr als 1 400 Werke von renommierten Künstlern und Newcomern sind als handsignierte Originale in limitierter Auflage erhältlich. Die Galerie liegt nur einige Gehminuten von der historischen Altstadt entfernt und bringt durch wechselnde Ausstellungen und Events Kunstbegeisterte aus ganz Hamburg zusammen.

LUMAS

ABC-Straße 51 // Neustadt
Tel.: +49 (0)40 3 89 04 86 0
www.lumas.de

Mon–Fri 10 am to 8 pm
Sat 10 am to 7 pm

U2 Gänsemarkt

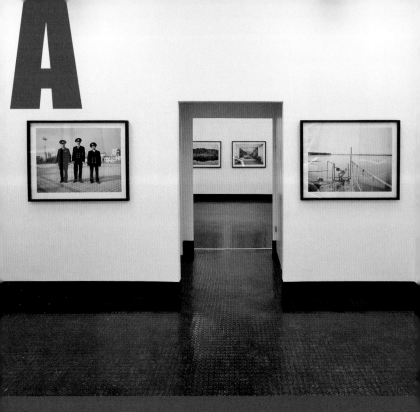

When the journalist Robert Morat was 32 years old, he uttered the desire to establish a gallery, but people told him that it would take seven years before he could get it up and running. He did not want to waste a single second so he opened his exhibition space for contemporary photography in the year 2004. He had to expand in 2006, and since 2010 there has been a branch in Berlin. Robert Morat achieved success by only displaying current items.

Als der Journalist Robert Morat 32 Jahre alt wurde, sagte man ihm, es würde sieben Jahre dauern, bis man eine Galerie etablieren und diese sich selbst tragen könne. Da wollte er keine Zeit verlieren und eröffnete 2004 seinen Ausstellungsraum für zeitgenössische Fotografie. Schon 2006 musste er räumlich expandieren und seit 2010 gibt es eine Dependance in Berlin. Mit dem Konzept der Präsentation ausschließlich aktueller Positionen ging für Robert Morat die Erfolgsrechnung auf.

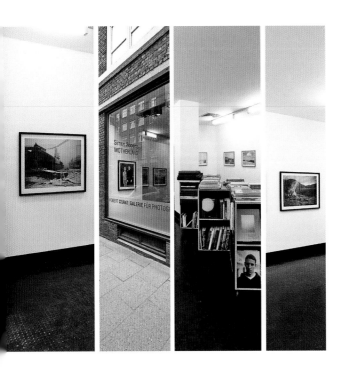

ROBERT MORAT GALERIE

Kleine Reichenstraße 1 // Neustadt
Tel.: +49 (0)40 32 87 08 90
www.robertmorat.de

Tue–Fri noon to 6 pm
Sat noon to 4 pm
and on appointment
U1 Meßberg

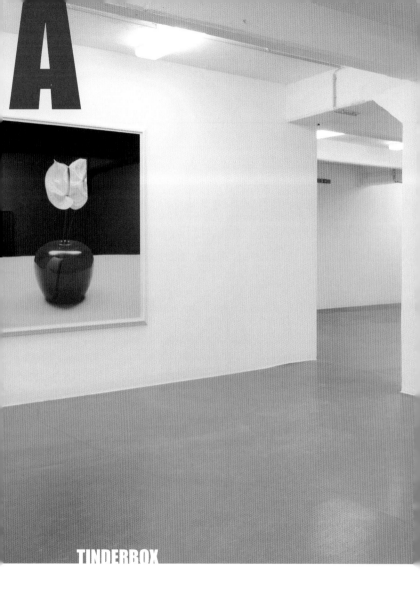
TINDERBOX

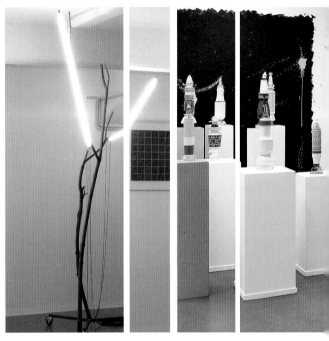

TINDERBOX

Admiralitätstraße 71 // Neustadt
Tel.: +49 (0)40 52 59 93 81
www.tinderbox-art.com

Tue–Fri 10 am to 6 pm
Sat 11 am to 3 pm
S1, S2, S3 Stadthausbrücke
U3 Rödingsmarkt

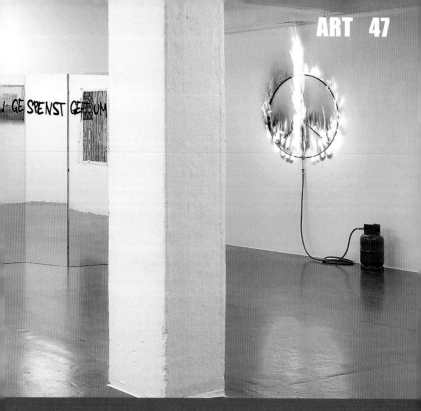

Works of art must have artistic and social relevance in order to attract the attention of Diane Kruse. This gallery owner does not confine herself to a particular school or medium; instead, she is open to all types of art. She exhibits increasingly international artists in her rooms on Admiralitätstraße, on a "small, enchanted island," as she passionately calls the area between two loading canals in the middle of the city.

Eine künstlerische und gesellschaftliche Relevanz sollten Arbeiten haben, um das Interesse von Diane Kruse zu wecken. Dabei legt sich die Galeristin nicht auf eine bestimmte Schule oder ein besonderes Medium fest, sondern lässt sich auf alle Spielarten der Kunst ein. Die zunehmend internationalen Künstler stellt sie in ihren Räumen in der Admiralitätstraße aus, auf einer „kleinen, verwunschenen Insel", wie sie das Gebiet zwischen zwei Fleeten inmitten der Stadt leidenschaftlich nennt.

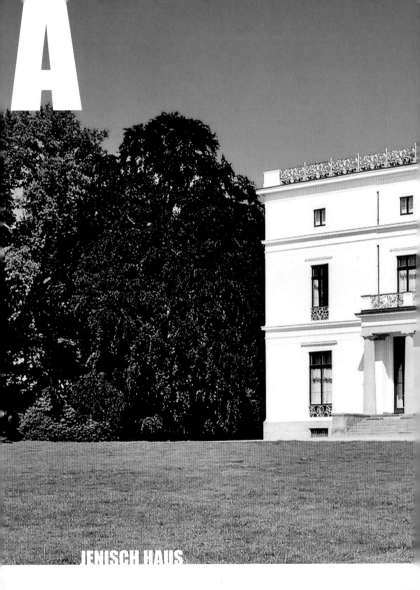

A

JENISCH HAUS

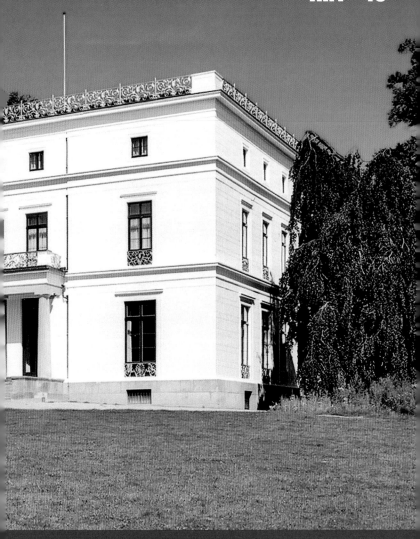

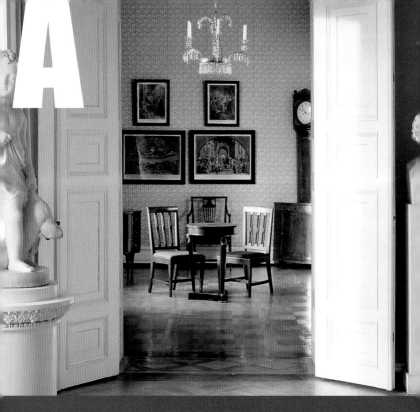

A

The former country house of the Hamburg senator Martin Johann Jenisch the younger was completed by Franz Gustav Forsmann and Karl Friedrich Schinkel in 1834. In the basement and on the first floor of this neoclassical villa, visitors wander through decorated rooms with magnificent furnishings from when the house was built, while on the upper floor, there are changing exhibitions with works from different epochs. The café with its view of the surrounding park invites you to stay a while.

Der ehemalige Landsitz des Hamburger Senators Martin Johann Jenisch d. J. wurde nach Entwürfen von Franz Gustav Forsmann und Karl Friedrich Schinkel 1834 fertiggestellt. Im Untergeschoss und der ersten Etage der klassizistischen Villa wandelt der Besucher durch stuckverzierte Säle mit prunkvoller Einrichtung aus der Entstehungszeit, während im Obergeschoss wechselnde Ausstellungen mit Werken verschiedener Epochen zu sehen sind. Das Café mit Blick in den umgebenden Park lädt zum Verweilen ein.

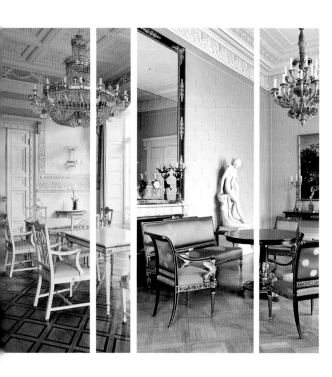

JENISCH HAUS

Baron-Voght-Straße 50 // Klein Flottbek
Tel.: +49 (0)40 82 87 90
www.altonaermuseum.de

Tue–Sun 11 am to 6 pm
S1, S11 Klein Flottbek

Some of the most expensive paintings in the world have been auctioned at Sotheby's, including Picasso's "Boy with a Pipe." Samuel Baker established this famous auction house in London in 1744; today there are 100 branch offices worldwide, one of which is in Hamburg. Visitors to the exhibition rooms can see art works before their auction in London or at other Sotheby's branches. Furthermore, it is also possible to have art and valuables appraised here free of charge.

Sotheby's versteigert Gemälde, die zu den teuersten der Welt zählen, wie Picassos „Junge mit Pfeife". Bereits 1744 gründete Samuel Baker das berühmte Auktionshaus in London, heute gibt es weltweit 100 Niederlassungen, eine davon in Hamburg. Hier können Besucher in den Ausstellungsräumen Kunstwerke vor ihrer Versteigerung in London oder anderen Sotheby's-Dependancen besichtigen. Außerdem ist es möglich, von Experten kostenlos Kunst- und Wertgegenstände schätzen zu lassen.

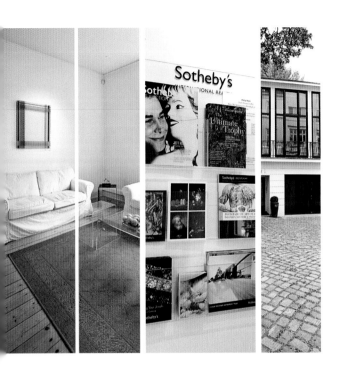

SOTHEBY'S HAMBURG

Tesdorpfstraße 22 // Rotherbaum
Tel.: +49 (0)40 44 40 80
www.sothebys.com

Mon–Fri 9 am to 5 pm
S11, S21, S31 Hamburg Dammtor
Bus 109 Fontenay

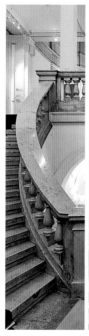

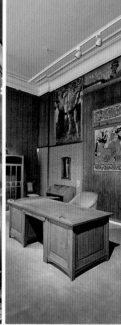

MUSEUM FÜR
KUNST UND GEWERBE

Steintorplatz // St. Georg
Tel.: +49 (0)40 4 28 13 48 80
www.mkg-hamburg.de

Tue–Sun 11 am to 6 pm
Thu 11 am to 9 pm
S1, S2, S3, S11, S21, S31, U1, U2, U3 Hauptbahnhof

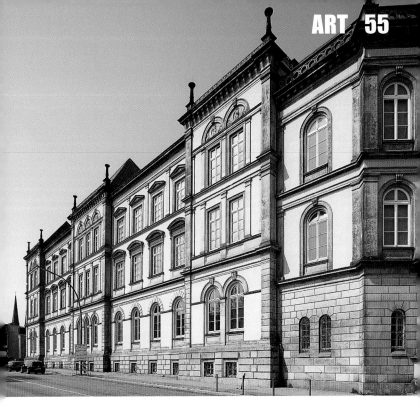

The broad spectrum of themes that is covered by the diverse collections of this traditional museum is highly impressive. Visitors' eyes are opened to the wonders of ancient Greek and Roman sculpture, art nouveau interior design, and the famous canteen that Verner Panton originally designed for the news magazine Der Spiegel. The collection of these diverse design forms under a single roof allows references to be drawn, and connections between art and the economy are plain to the eye.

Das traditionsreiche Museum beeindruckt durch ein breites thematisches Spektrum, das sich in vielen unterschiedlichen Sammlungen manifestiert. Dem Besucher eröffnet sich ein Blick auf die Bildhauerkunst der Antike, das Interieur des Jugendstils oder auf die ins Haus transferierte Kantine des Magazins Der Spiegel von Verner Panton. Mit der Versammlung der diversen Formen von Gestaltung unter einem Dach werden Bezüge hergestellt, und Zusammenhänge zwischen Kunst und Wirtschaft treten deutlich hervor.

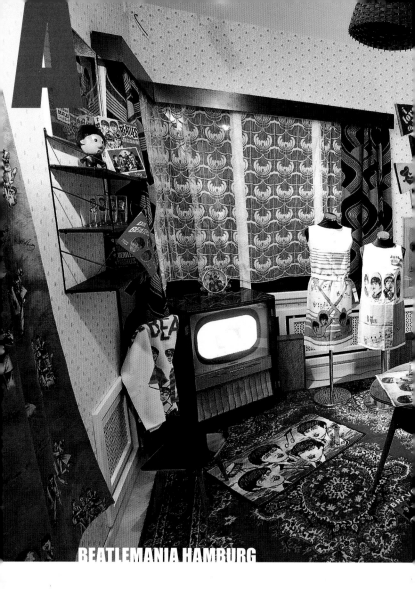

BEATLEMANIA HAMBURG

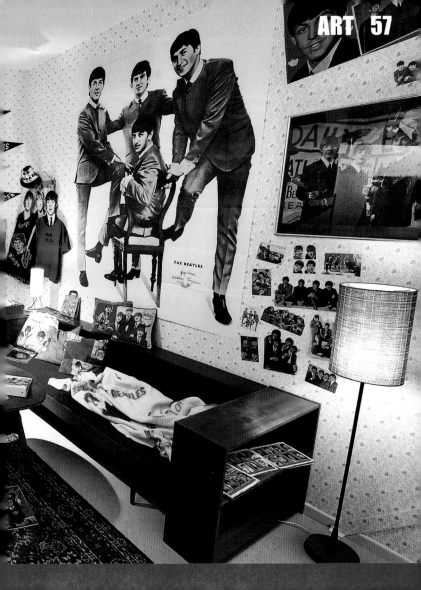

THE BEATLES

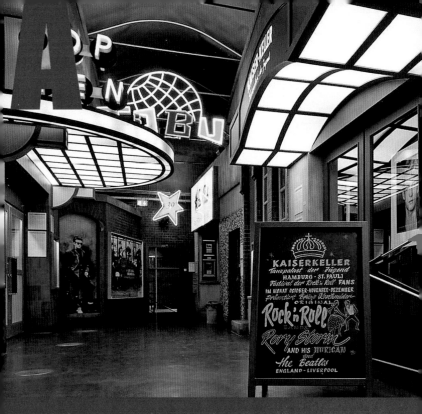

Not without reason are five stories of exhibition space dedicated to this famous pop group. Their stay in Hamburg in the early 60s left a noticeable mark on the musicians' identity as a band; this was the time in which the rebellious mushroom-head haircut arose, for example. With original exhibits, photos, audio and video recordings in eleven different themed rooms, as well as a multitude of tours, Beatlemania is dedicated to the cultural and social significance of The Beatles and is an entertaining exhibition.

Nicht grundlos werden der berühmten Popgruppe hier fünf Etagen Ausstellungsfläche gewidmet. Die Hamburger Zeit Anfang der 60er prägte die Musiker stark in ihrer Identität als Band, damals entstand beispielsweise die rebellische Pilzkopf-Frisur. Mit Originalexponaten, Fotos, Audio- und Videoaufnahmen in elf verschiedenen Themenräumen sowie einem facettenreichen Angebot an Führungen widmet sich Beatlemania auf unterhaltsame Weise der kulturellen und gesellschaftlichen Bedeutung der Beatles.

BEATLEMANIA HAMBURG

Nobistor 10 / Reeperbahn // St. Pauli
Tel.: +49 (0)40 31 17 18 18
www.beatlemania-hamburg.com

Mon–Sun 10 am to 7 pm
S1, S2, S3 Reeperbahn
Bus 36, 37, 283 Reeperbahn

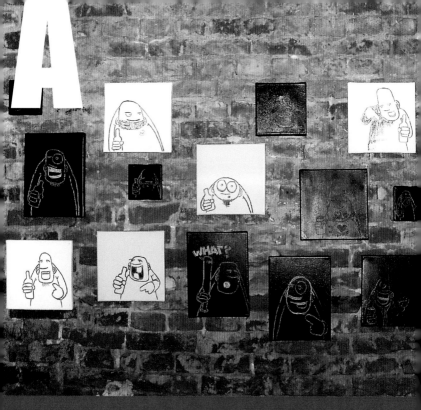

People have been defying commerce here since 2008. Christian Wegehenkel and Marc Rosswurm want to keep their little off-space playful; therefore, they will probably never exhibit anybody with whom they cannot also celebrate a wild private viewing. In addition to changing exhibitions that feature a selection of young artists, the regular feature is "Stän-dig auf Halb Acht," that is, "constantly at seven-thirty." The gallery presents a lot of graphic art influenced by comics, graffiti, and street art.

Seit 2008 trotzt man hier dem Kommerz. Christian Wegehenkel und Marc Rosswurm möchten den Spaß an ihrem kleinen Off-Space nicht verlieren, und deswegen würden sie wahrscheinlich niemanden ausstellen, mit dem sie nicht auch eine wilde Vernissage feiern könnten. „Ständig auf Halb Acht" ist der Präsenzbestand neben wechselnden Ausstellungen, der eine Auswahl junger Künstler dauerhaft zeigt. Die Galerie präsentiert überwiegend von Comic, Graffiti und Streetart beeinflusste Grafiken.

GALERIE AUF HALB ACHT

Hein-Hoyer-Straße 16 // St. Pauli
Tel.: +49 (0)40 76 99 26 56
www.aufhalbacht.de

Thu–Fri 4 pm to 7.30 pm, Sat 1 pm to 6 pm
and on appointment

S1, S2, S3 Reeperbahn, U3 St. Pauli

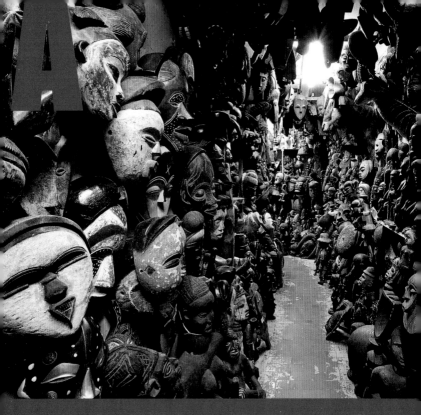

This unusual mixture of folk art gallery and souvenir sales room opened in the 1950s. When sailor Harry Rosenberg retired in Hamburg and interest in the objects he had brought back from his travels grew, he opened the bazaar, in which he offered, in addition to the souvenirs, the bequest of a certain Captain Haase. Things from all around the world appear here, which you can examine and buy.

Bereits in den 50er Jahren eröffnete diese außergewöhnliche Mixtur aus Galerie für Volkskunst und Verkaufsraum für Souvenirs. Als sich Seefahrer Harry Rosenberg damals in Hamburg zur Ruhe setzte und das Interesse an den von seinen Reisen mitgebrachten Objekten wuchs, eröffnete er den Basar, in dem er neben eigenen Mitbringseln z. B. auch den Nachlass eines gewissen Käpt'n Haase anbot. Bis heute werden hier Dinge aus aller Welt herbeigeschafft, die man besichtigen, aber auch kaufen kann.

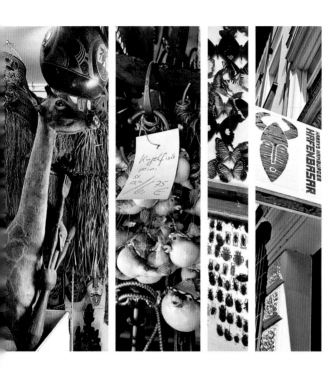

HARRYS HAMBURGER HAFENBASAR

Erichstraße 56 // St. Pauli
Tel.: +49 (0)40 31 24 82
www.hafenbasar.de

Thu–Sun noon to 6 pm
and on appointment

S1, S2, S3 Reeperbahn

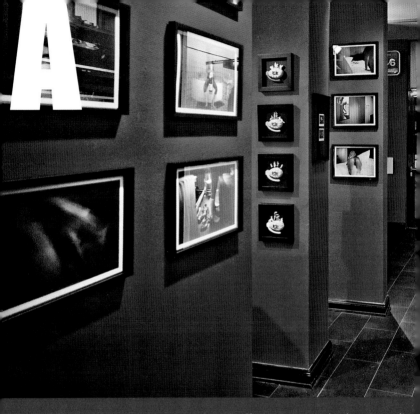

A

Graffiti, street art, and urban art—the Vicious Gallery gives street art a roof to live under. Even if such forms of expression have already progressed from subculture to the art establishment—the Briton Banksy is a famous example—the allure of the subversive lives on. In changing exhibitions, the gallery shows newcomers to the scene as well as famous artists such as Stefan Strumbel and Dave the Chimp.

Graffiti, Streetart und Urban Art – die Vicious Gallery ist ein Ort, an dem Kunst von der Straße ein Dach über dem Kopf hat. Auch wenn diese Ausdrucksformen bereits den Weg aus der Subkultur in das Kunst-Establishment eingeschlagen haben – ein berühmtes Beispiel dafür ist der Brite Banksy – so haftet ihr immer noch der Reiz des Subversiven an. Die Galerie zeigt in wechselnden Ausstellungen neben bekannten Künstlern wie Stefan Strumbel oder Dave the Chimp auch Newcomer der Szene.

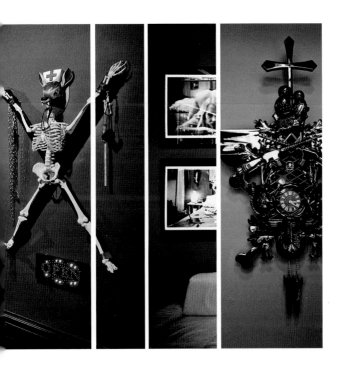

VICIOUS GALLERY

Kleine Freiheit 46 // St. Pauli
Tel.: +49 (0)40 67 30 56 53
www.viciousgallery.com

Wed–Sat 1 pm to 7 pm
S1, S2, S3 Reeperbahn

ARCHIT

ECTURE

"More visionary architecture for Hamburg!" called Hadi Teherani, and he let his gaze wander along the Elbe. This story is a fabrication, but who knows whether things did not happen this way? With his partners at BRT, the architect has been shaping the cityscape of Hamburg for many years. Giant office towers of steel and glass are his answer to the sophisticated brick buildings of the 1920s, especially Fritz Höger's Chilehaus and the imposing Sprinkenhof. But Hamburg has also let other significant architects build, such as the American Richard Meier, the Briton David Chipperfield, and the Swiss Herzog & de Meuron, who with the Elbphilharmonie are erecting what might become one of the most spectacular buildings in the world. The city expansion associated with HafenCity has succeeded despite all criticism, for a highly stimulating area has been created to contrast with the surrounding water. Thus, the beloved Speicherstadt also loses its position on the fringes and is being used increasingly as a place to live and work.

„Mehr visionäre Architektur für Hamburg!", rief Hadi Teherani und ließ seinen Blick über die Elbe schweifen. Dieser Vorfall ist zwar frei erfunden, aber wer weiß, ob das so nicht vorgekommen ist. Der Architekt prägt mit seinen Partnern bei BRT seit vielen Jahren das Stadtbild Hamburgs. Riesige Bürohäuser aus Stahl und Glas sind seine Antwort auf die mondänen Backsteinbauten der 20er Jahre, allen voran Fritz Högers Chilehaus oder der imposante Sprinkenhof. Aber Hamburg lässt auch andere bedeutende Architekten für sich bauen, wie den Amerikaner Richard Meier, den Briten David Chipperfield oder die Schweizer Herzog & de Meuron, die mit der Elbphilharmonie wahrscheinlich eines der spektakulärsten Gebäude der Welt errichten. Die mit der HafenCity verbundene Stadterweiterung ist trotz aller Kritik gelungen, denn man hat ein durch das allgegenwärtige Wasser sehr reizvolles Areal hinzugewonnen. Dadurch verliert auch die beliebte Speicherstadt ihre Randlage und wird verstärkt als Wohn- und Arbeitsort genutzt.

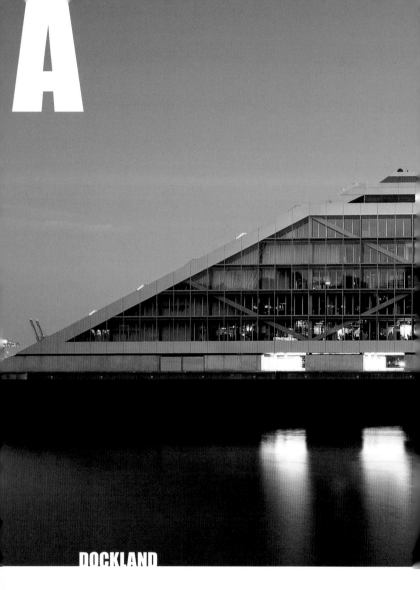

A

DOCKLAND

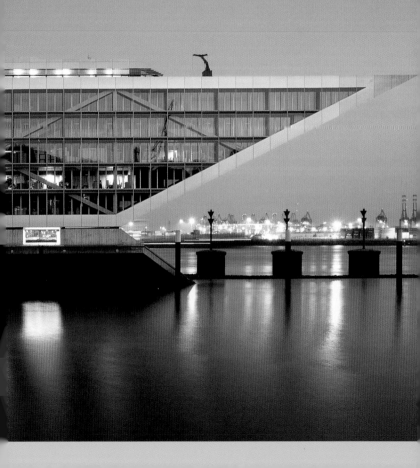

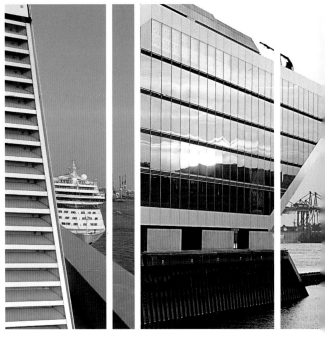

DOCKLAND

Van-der-Smissen-Straße 9 // Altona-Altstadt
www.dockland-hamburg.de

S1, S2, S3 Königstraße
HVV-Hafenfähre Linie 61, 62 Dockland (Fischereihafen)

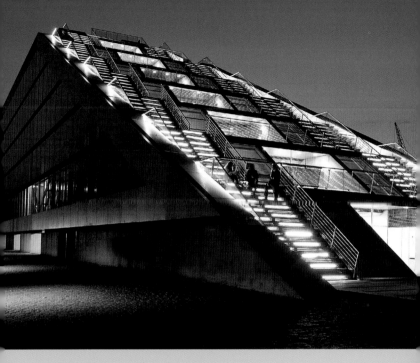

This spectacular building by the Hamburg BRT Architekten is reminiscent of a ship and protrudes more than 130 ft. from the Edgar-Engelhard-Kai out over the water. With its publicly-accessible roof terrace, which can be reached via a broad outdoor staircase on the rear of the building, Dockland looks like a friendly giant, welcoming visitors onto its back. This office building, which is borne by a clever steel construction and encompasses approximately 97,000 sq. ft., has already won numerous awards.

Über 40 m kragt der spektakuläre, an ein Schiff erinnernde Bau der Hamburger BRT Architekten vom Edgar-Engelhard-Kai auf das Wasser hinaus. Mit der öffentlich zugänglichen Dachterrasse, die über eine breite Freitreppe am Heck des Gebäudes zu erreichen ist, gibt sich das Dockland wie ein freundlicher Riese, der Besucher auf seinem Rücken willkommen heißt. Das von einer kühnen Stahlkonstruktion getragene, rund 9 000 m² Fläche bietende Bürogebäude erhielt bereits mehrfach Auszeichnungen.

HADI
TEHERA

NI

As the creative head of the architecture office BRT, the native Iranian has been making an impression, together with Jens Bothe and Kai Richter, on the image of Hamburg for approximately 20 years. The dancing towers on the Reeperbahn, the Berlin arch, Süd-Carré, and Dockland—his buildings extend like glass monuments into the Hanseatic sky. Teherani grew up in Hamburg, studied architecture in Braunschweig, and lived in various other places, before returning to the city in 1992. The architect is a positive visionary: with the ideas of the Bauhaus and the ecological requirements of today, he would like to design the future. In so doing, he wants Hamburg to have an even stronger architectonic relationship with water, which he demonstrated with the design of his spectacular "living bridge" and the urban growth south of the Elbe. But Teherani is not just a designer of the "outside," but also increasingly of the "inside." The "Silver Chair" office chair that he designed has already appeared in Hollywood films.

Als kreativer Kopf des Architekturbüros BRT prägt der gebürtige Iraner zusammen mit Jens Bothe und Kai Richter das Stadtbild Hamburgs seit rund 20 Jahren entscheidend mit. Die tanzenden Türme an der Reeperbahn, der Berliner Bogen, Süd-Carré oder Dockland – seine Bauten ragen wie gläserne Monumente in den hanseatischen Himmel. Teherani wuchs in Hamburg auf, studierte in Braunschweig Architektur und kehrte nach anderen Stationen 1992 hierher zurück. Der Architekt ist ein positiver Visionär: Mit den Ideen des Bauhaus und den ökologischen Anforderungen von heute möchte er die Zukunft gestalten. Dabei wünscht er sich für Hamburg einen noch stärkeren architektonischen Bezug zum Wasser, den er mit dem Entwurf seiner spektakulären „Living Bridge" bereits demonstrierte, sowie städtebauliches Wachstum auch südlich der Elbe. Aber Teherani ist nicht nur Gestalter des „Außen", sondern zunehmend auch des „Innen". Der von ihm designte Bürostuhl „Silver Chair" tauchte bereits in Hollywoodfilmen auf.

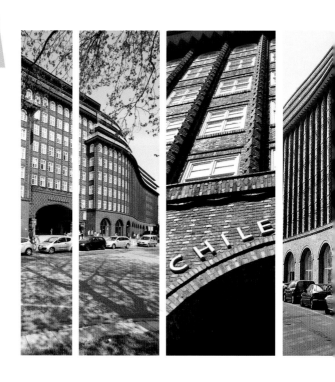

CHILEHAUS

Fischertwiete 2 // Altstadt
www.chilehaus.de

U1 Meßberg

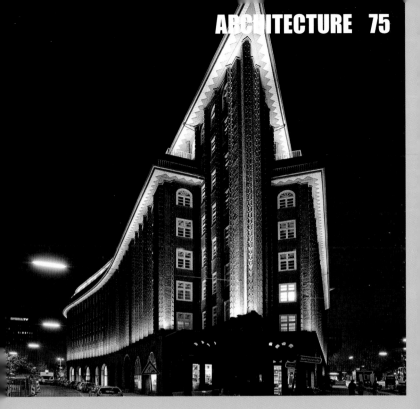

Once upon a time, the merchant Henry B. Sloman emigrated to Chile with no money to his name. When he returned to his native city of Hamburg at the age of 60, now a rich man, he had the Chilehaus built by the renowned architect Fritz Höger, who later also helped construct the Sprinkenhof. The building has an area of more than 64,000 sq. ft. and its powerful, patterned brick facade is impressive. The characteristic eastern peak is now and always has been a beloved photo motif.

Einst wanderte der Kaufmann Henry B. Sloman mittellos nach Chile aus. Als er 60jährig, inzwischen zu Reichtum gekommen, in seine Heimatstadt Hamburg zurückkehrte, ließ er das Chilehaus durch den Architekten Fritz Höger errichten, der später auch maßgeblich am Bau des Sprinkenhofs beteiligt war. Der Bau erstreckt sich über 5 950 m² und beeindruckt mit seiner mächtigen, gemusterten Klinkerfassade. Vor allem die charakteristische Ostspitze ist damals wie heute ein beliebtes Fotomotiv.

HAUS IM HAUS

Adolphsplatz 1 // Altstadt
www.hk24.de

U3 Rathaus

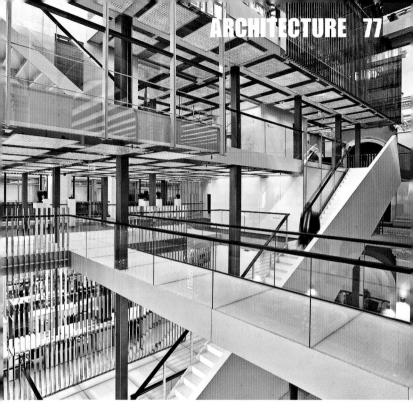

Behnisch Architekten designed a spectacular new five-story building to expand the chamber of commerce, which was erected inside the neoclassical stock exchange hall. The cubes connected by open staircases and bridges, lighted exclusively by LED lights, are complemented on the upper story by sophisticated meeting rooms with fabric-covered walls, Chesterfield chairs, and chandeliers—a reference to the historic opulence of the surrounding building.

Für die Erweiterung der Handelskammer entwarfen die Behnisch Architekten einen spektakulären, fünfstöckigen Neubau, der im Inneren der alten klassizistischen Börsenhalle errichtet wurde. Die durch Freitreppen und Brücken verbundenen, ausschließlich mit LED-Licht beleuchteten Würfel werden im oberen Geschoss durch mondäne Meetingräume mit stoffbespannten Wänden, Chesterfield-Sesseln und Kronleuchtern abgeschlossen – ein Verweis auf die historische Pracht des ergänzten Gebäudes.

This imposing building was erected in the 1920s as a residential and commercial space including warehouse in the Kontorhausviertel complex; the west and east wings were added in the 1930s and 1940s. As a good example of brick expressionism, which developed at the same time as the minimal Bauhaus, the ornamentation of the facade is striking, decorated with diamond-shapes and ceramic motifs. The Sprinkenhof today houses office space and stores, among other things.

Das imposante Gebäude wurde in den 20er Jahren als Wohn-, Geschäfts- und Lagerhaus im Bauensemble des Kontorhausviertels errichtet und bis in die 40er Jahre hinein durch West- und Ostflügel ergänzt. Als repräsentatives Beispiel des sich parallel zum reduktiven Bauhaus entwickelnden Backsteinexpressionismus weist die Fassade eine markante Ornamentik mit rautenförmiger Verzierung und Keramikmotiven auf. Der Sprinkenhof beherbergt heute unter anderem Büro- und Ladenflächen.

SPRINKENHOF

Altstädter Straße 6-8, Burchardstraße 8-14 // Altstadt
www.sprinkenhof-hamburg.de

U1 Steinstraße
U3 Mönckebergstraße

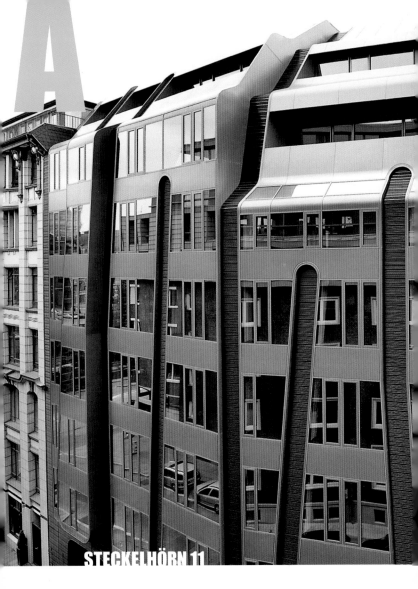

STECKELHÖRN 11

The windowed front of this ceramic-clad building looks as if J. Mayer H. Architekten had poured the windows over it. Looking at this office building, it is easy to see that the Berlin architect had already had a successful career in design. Its spectacular back is a slim sculpture just 6 ft. wide that rises up above the eaves of the neighboring buildings of the Katharinenfleet; it has thus positioned itself prominently on the skyline of the Hamburg old city since 2009.

Die Fensterfront des keramikverkleideten Baus wirkt, als hätten J. Mayer H. Architekten sie abschließend einfach darüber gegossen. Dass die Berliner Architekten schon erfolgreich im Designbereich gearbeitet haben, sieht man dem Bürogebäude an. Die spektakuläre Rückseite erhebt sich mit etwa 1,8 m Breite als schmale Skulptur über die Traufenhöhen der Nebengebäude des Katharinenfleet und positioniert sich damit seit 2009 prominent in der Skyline der Hamburger Altstadt.

STECKELHÖRN 11

Steckelhörn 11 // Altstadt

S1, S2, S3 Stadthausbrücke
U1 Meßberg

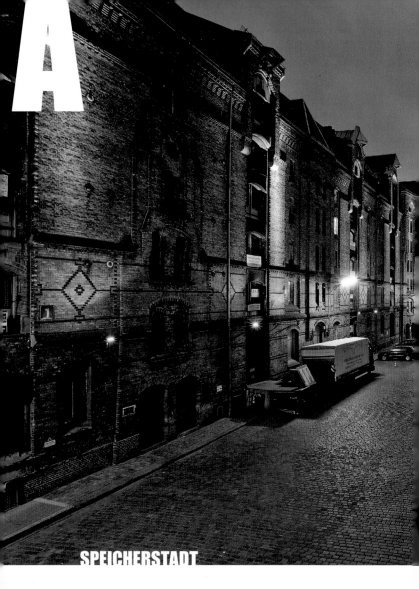

A

SPEICHERSTADT

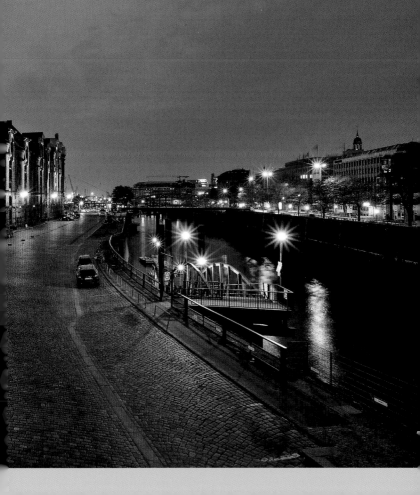

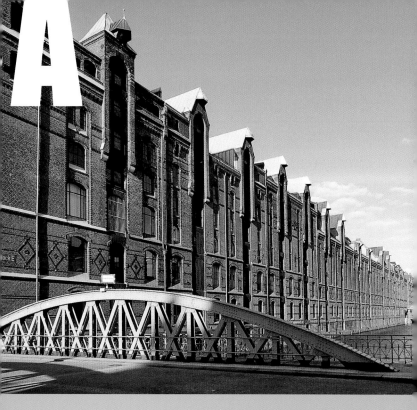

The neo-Gothic battlements of Speicherstadt are visible from far and wide, projecting into the Hamburg sky. Erected between 1885 and 1927 on the "Brookinseln," it was the most modern warehouse complex in the world. In the Speicherstadt museum, surrounded by old equipment, visitors learn e.g. what the task of the inhabitants was or what "Fleeten" are. An evening stroll is recommended: when the setting sun illuminates the brick, you will be in for a visual treat.

Weit sichtbar ragen die neugotischen Zinnen der Speicherstadt in den Hamburger Himmel. Zwischen 1885 und 1927 auf den Brookinseln errichtet, war sie damals der modernste Lagerhauskomplex der Welt. Im Speicherstadtmuseum erfährt man inmitten alter Gerätschaften, was z. B. die Aufgabe der Quartiersleute war oder was „Fleeten" sind. Auch ein Abendspaziergang ist zu empfehlen: Wenn die untergehende Sonne das Rot der Backsteine zum Leuchten bringt, ist das ein spektakulärer Anblick.

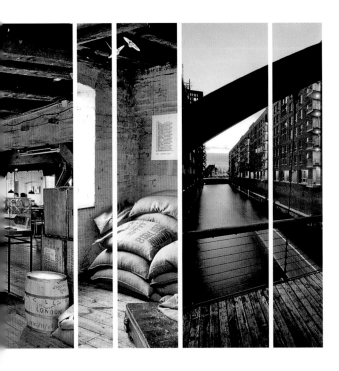

SPEICHERSTADT

HafenCity
www.speicherstadtmuseum.de

U3 Baumwall

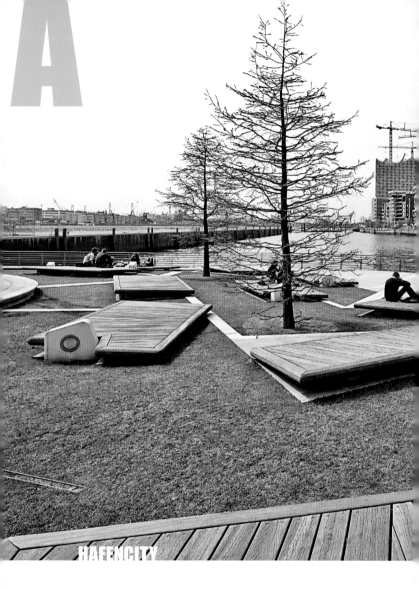

A

HAFENCITY

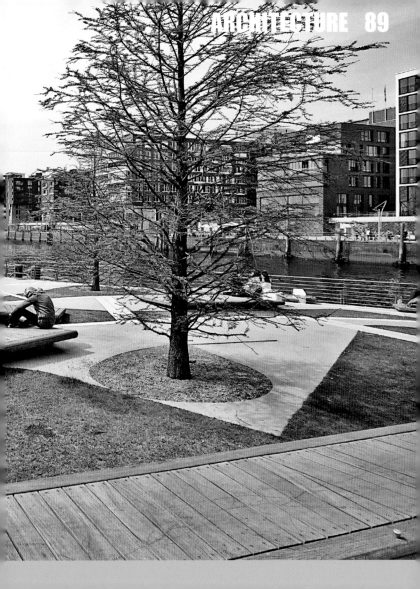

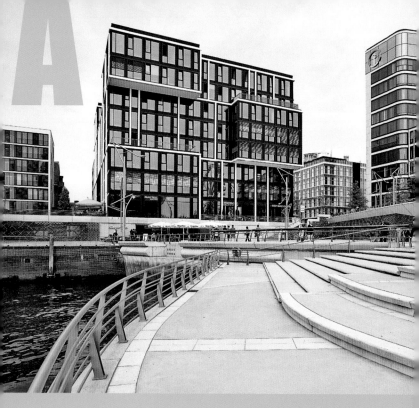

After devoting several years to studies, the new urban design for the fallow inner city edge of the harbor was approved in 2000. The master plan for HafenCity includes approximately 388 acres of new construction—and thus an expansion of the original inner city by 40%. The largest urban development project in Europe today seeks to take into consideration historic harbor structures and existing buildings, as well as the adjacent Speicherstadt.

Nachdem man einige Jahre mit Studien verbracht hatte, wurde im Jahr 2000 das neue städtebauliche Konzept für den brachliegenden Hafenrand beschlossen. Der Masterplan für die HafenCity sieht eine Neubebauung von rund 157 ha vor – und damit eine Expansion der ursprünglichen Innenstadt um 40%. Das derzeit größte innerstädtische Stadtentwicklungsprojekt Europas möchte dabei historische Hafenstrukturen und erhalten gebliebene Bestandsbauten sowie die angrenzende Speicherstadt berücksichtigen.

HAFENCITY

HafenCity
www.hafencity.com

U1 Baumwall
U3 Meßberg

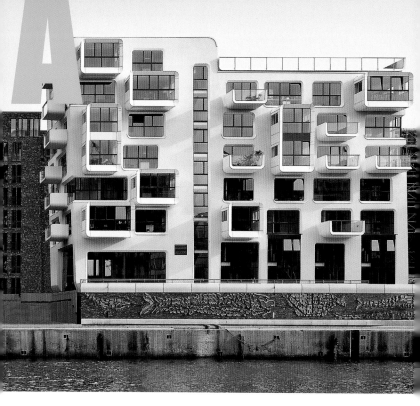

Thanks to its strictly-organized facade with rounded-off edges and protruding balconies, this residential building designed by the LOVE architects seems almost playful amidst the straight lines of the surrounding buildings. This building, completed in 2008, is on a spit of land in the Dalmannquartier for which a mixed-use development of residences, offices and stores was designed. The only skyscraper project here is the Elbphilharmonie, which borders the area to the west.

Durch die stark gegliederte Fassade mit den abgerundeten Kanten und auskragenden Balkons wirkt das von den LOVE architects entworfene Wohnhaus fast schon verspielt inmitten der Geradlinigkeit der umstehenden Gebäude. Das 2008 fertiggestellte Objekt befindet sich auf einer Landzunge im Dalmannquartier, für das eine Mischnutzung aus Wohnungen, Büros und Ladenflächen realisiert werden konnte. Das einzige Hochbauprojekt ist hier die Elbphilharmonie, die das Gebiet westlich begrenzt.

AM KAISERKAI 56

Am Kaiserkai 56 // HafenCity
www.buergerstadt.de

U3 Baumwall

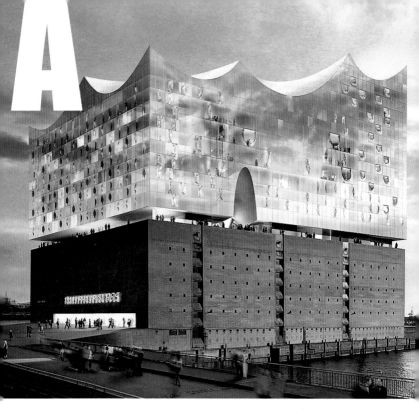

Like a being from another world, the glass body by the Swiss architects Herzog & de Meuron sits atop the old warehouse building. For optimal sound insulation, the large concert hall is held up only by steel springs, and it is designed like the terraces of a vineyard; the audience is grouped in a circle around the orchestra. In the Elbphilharmonie-Pavilion, you can have a look at the model (scale 1:10) in which the sound tests were conducted.

Wie ein Wesen aus einer anderen Welt sitzt der gläserne Korpus der Schweizer Architekten Herzog & de Meuron auf dem alten Speichergebäude. Der große Konzertsaal, der, um eine akustische Isolierung zu erreichen, nur von Stahlfedern gehalten wird, ist nach dem Weinberg-Konzept entworfen worden. Hier gruppieren sich die Zuschauer kreisförmig um das Orchester herum. Im Elbphilharmonie-Pavillon kann das Modell (Maßstab 1:10) besichtigt werden, in dem die Klangmessungen durchgeführt wurden.

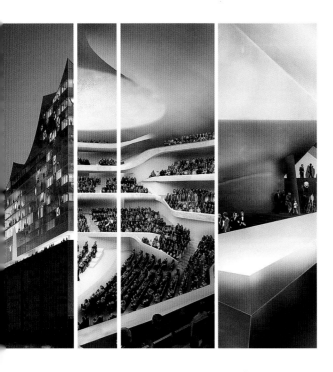

ELBPHILHARMONIE HAMBURG

Am Kaiserkai // HafenCity
Tel.: +49 (0)40 35 76 66 66
www.elbphilharmonie.de

U3 Baumwall

The 180 ft. high building by Behnisch Architekten looks like a sculpture that marks the end of the route leading from the inner city through HafenCity to the promenade on the Strandkai. The spiraled stacking of the stories results from floors that are built one atop another offset by a few degrees. Each of the 58 high-priced private apartments therefore has a clear view of the harbor and the city. This luxury building is oriented towards sustainability with a modern energy strategy.

Das 55 m hohe Gebäude der Behnisch Architekten wirkt wie eine Skulptur, die das Ende der Route markiert, die aus der Innenstadt durch die HafenCity zur Promenade am Strandkai führt. Die spiralige Staffelung der Etagen resultiert aus den je um einige Grad versetzt übereinander gebauten Stockwerken. Jedes der 58 hochpreisigen Privat-Appartements hat dadurch einen freien Blick auf den Hafen und über die Stadt. Mit einem modernen Energiekonzept ist der Luxusbau auf Nachhaltigkeit ausgerichtet.

MARCO POLO TOWER

Hübenerstraße 1 // HafenCity
www.marcopolotower.com

U1 Meßberg
U3 Baumwall

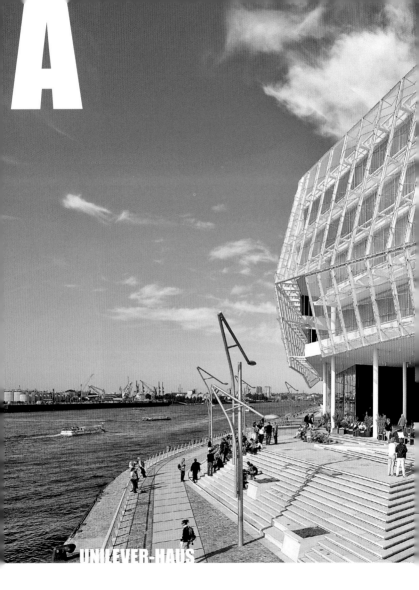

A

UNILEVER-HAUS

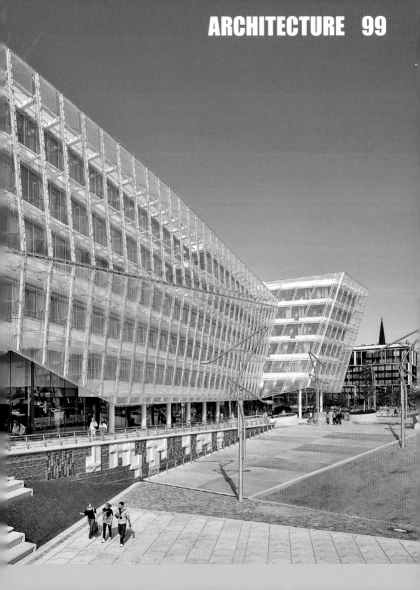

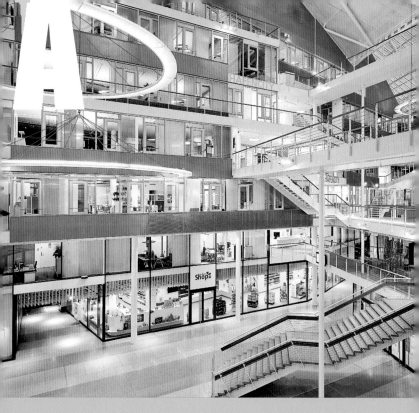

The brand manufacturer Unilever presents itself in contemporary fashion with this dynamic building, which is covered in a spectacular foil. In the group central office on the bank of the Elbe, visitors can wander through the atrium, purchase the company's products in the shop, visit the café or even a spa. Like the neighboring Marco Polo Tower, this building was also designed by Behnisch Architekten and equipped with a modern energy strategy.

Mit diesem dynamischen Gebäude, das von einer spektakulären Folie ummantelt wird, präsentiert sich der Markenhersteller Unilever zeitgemäß offen. In der Konzernzentrale am Ufer der Elbe können Besucher durch das Atrium schlendern, im Shop hauseigene Produkte kaufen, das Café oder sogar einen Spa besuchen. Wie der benachbarte Marco Polo Tower wurde auch dieses Gebäude von Behnisch Architekten entworfen und mit einem modernen Energiekonzept ausgestattet.

UNILEVER-HAUS

Strandkai 1 // HafenCity
www.unilever.de

U1 Meßberg
U3 Baumwall

SÜD-CARRÉ

Hammerbrookstraße 69 // Hammerbrook

S3, S31 Hammerbrook

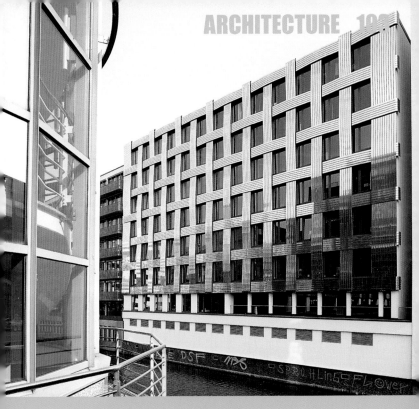

This building from 1962 has been expanded to include two seven-story bodies and a connecting building to form a new office building ensemble. In the hole facade of positively and negatively-bent high-gloss stainless steel bands, which overlap into a giant tapestry, there arise light reflexes and reflections which make the building appear noteworthy and extravagant and manifest the style of BRT Architekten in Hamburg in another work of new, exciting architecture.

Das Bestandsgebäude aus dem Jahr 1962 wurde mit zwei siebengeschossigen Baukörpern und einem Verbindungsbau zu einem neuen Bürohausensemble erweitert. In der Lochfassade aus positiv und negativ gebogenen, hochglänzenden Edelstahlbändern, die sich in einem riesigen Flechtwerk überlagern, entstehen Lichtreflexe und Spiegelungen, die den Bau auffällig und extravagant erscheinen lassen – und als ein weiteres Werk neuer, spannungsreicher Architektur den Stil der BRT Architekten in Hamburg manifestieren.

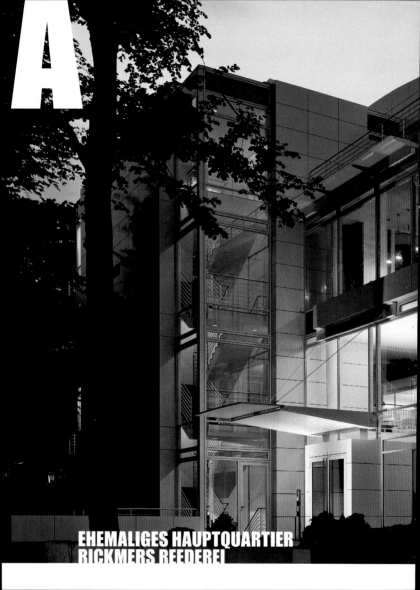

A

**EHEMALIGES HAUPTQUARTIER
RICKMERS REEDEREI**

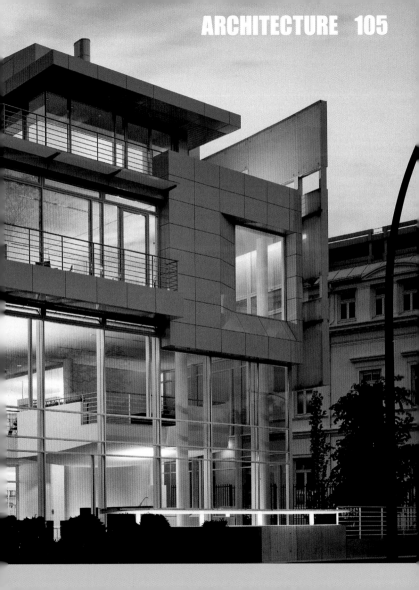

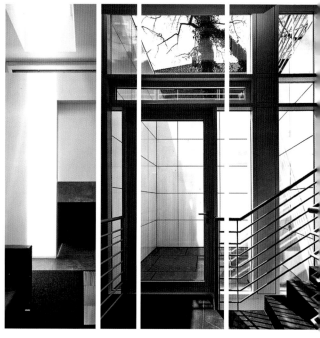

EHEMALIGES HAUPTQUARTIER RICKMERS REEDEREI

Alsterufer 26 // Rotherbaum

S11, S21, S31 Hamburg Dammtor
U1 Stephansplatz

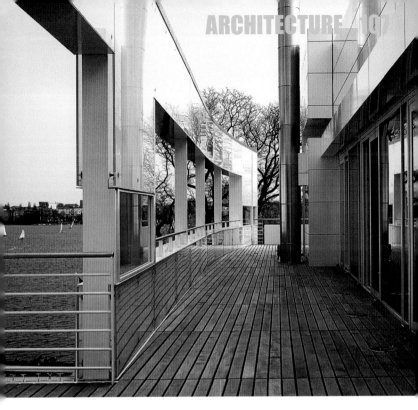

The American architect Richard Meier, who is an admirer of Le Corbusier, is a true champion of modern architecture. Especially the radiant white, in which he dips his functional, reduced buildings, characterizes his very personal brand. With this building, Meier created a typical example of his own aesthetic taste: large expanses of glass, which direct the gaze from inside to outside, and an open building structure that plays with light and shadow.

Der amerikanische Architekt Richard Meier, der ein Bewunderer Le Corbusiers ist, gilt als treuer Verfechter der Moderne. Vor allem das strahlende Weiß, in das er seine funktional reduzierten Bauten taucht, gilt inzwischen als sein ganz persönliches Markenzeichen. Mit diesem Objekt schuf Meier ein typisches Referenzstück seiner eigenen Ästhetik: große Glasflächen, die den Blick von innen nach außen lenken und eine offene, mit Licht und Schatten spielende Gebäudestruktur.

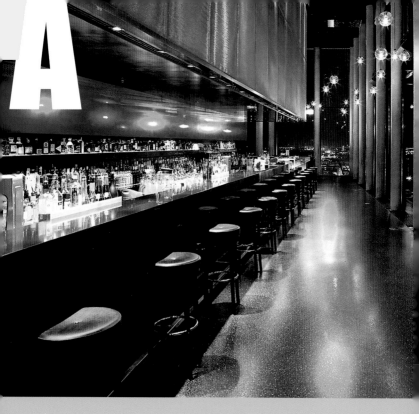

A

A skyscraper in the middle of St. Pauli! This building reaches more than 295 ft. into the sky above the former Bavaria grounds. The famous British architect David Chipperfield built and furnished this hotel, which opened in 2007. Visible from afar is its bronze-colored facade, for which 120 tons of bronze were used. This material is used inside the building too, alongside wood, leather, and glass. In the Skybar, giant panoramic windows offer a sensational view of the city.

Ein Wolkenkratzer mitten in St. Pauli! Über 90 m ragt der Bau auf dem ehemaligen Bavaria-Gelände in den Himmel. Der britische Architekt David Chipperfield hat das 2007 eröffnete Hotel gebaut und ausgestattet. Weithin sichtbar ist die bronzefarbene Fassade, für die 120 Tonnen Baubronze verbraucht wurden. Auch im Inneren findet sich das Material neben Holz, Leder und Glas wieder. In der Skybar bieten riesige Panoramafenster einen sensationellen Blick über die Stadt.

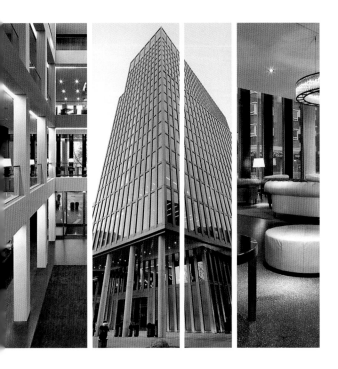

EMPIRE RIVERSIDE HOTEL

Bernhard-Nocht-Straße 97 // St. Pauli
Tel.: +49 (0)40 31 11 90
www.empire-riverside.de

S1, S2, S3 Reeperbahn
U3 St. Pauli

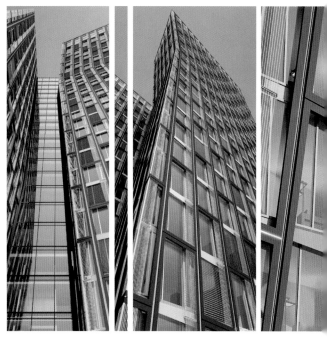

TANZENDE TÜRME

Reeperbahn 1 // St. Pauli

U3 St. Pauli

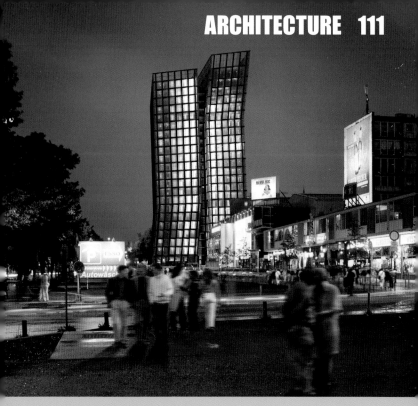

Architecture is influenced by its environment; every new house can be understood to be a contribution to what is already there. So it is no surprise that these towers are dancing, as they are right on the doorstep of the Reeperbahn. The expressive high-rise building with its two sections bent in two different directions sends good vibes over a great distance. The dynamic solitaire of BRT Architekten is a humorous reference to the lively entertainment district of St. Pauli.

Architektur ist von ihrer Umgebung beeinflusst, jedes neue Haus kann als Kommentar zu dem verstanden werden, was bereits da ist. So verwundert es nicht, dass diese Türme tanzen – denn sie stehen direkt am Anfang der Reeperbahn. Das expressive Hochhaus mit den zwei, in unterschiedliche Richtungen abgeknickten Gebäudeteilen verbreitet schon von weitem gute Laune. Der dynamische Solitär der BRT Architekten ist eine humorvolle Referenz an das lebhafte Vergnügungsviertel St. Pauli.

DESIGN

Design is an important topic in Hamburg. Famous people who have had their main offices here since the 1970s, the product designers Lothar Böhm and Peter Schmidt, for example, have been designing for many world brands since then. And younger agencies such as Landor Hamburg are represented internationally with branch offices and are among the elite of the corporate and brand design world. The Hamburg architect Hadi Teherani, who established his design agency here in 2003, is also successful with his designs, and three prominent fashion designers have close connections to the city: Jil Sander, Wolfgang Joop, and even Karl Lagerfeld, who was born here. Now the fashion hopes rest on Stefan Eckert. But Hamburg would not be Hamburg if, in the midst of high-end design and a feeling for the latest trend, there were no references to the roots of the old harbor city. With humor, the young designers develop their own understanding of style, in which shipping symbols, a little sailor's yarn, and the water always play a role.

Design ist in Hamburg ein großes Thema. Berühmtheiten, die hier ihre Stammbüros bereits seit den 70er Jahren betreiben, beispielsweise die Produktdesigner Lothar Böhm oder Peter Schmidt, gestalten seitdem für viele Weltmarken. Auch jüngere Agenturen wie Landor Hamburg sind international mit Dependancen vertreten und gehören zur Spitze der Corporate- und Branddesign-Riege. Der Hamburger Architekt Hadi Teherani, der hier 2003 seine Design-Agentur gründete, ist mit seinen Entwürfen ebenfalls erfolgreich, und drei prominente deutsche Modedesigner haben enge Verbindungen zu der Stadt: Jil Sander, Wolfgang Joop und sogar Karl Lagerfeld, der hier geboren wurde. Nun ruhen die Modehoffnungen auf Stefan Eckert. Aber Hamburg wäre nicht Hamburg, wenn es nicht inmitten von High End-Gestaltung und Trendgespür die Bezüge zu den Wurzeln der alten Hafenstadt geben würde. Mit Humor formen die jungen Designer ihr eigenes Style-Verständnis, in dem Symbole der Schifffahrt, ein bisschen Seemannsgarn und das Wasser immer eine Rolle spielen.

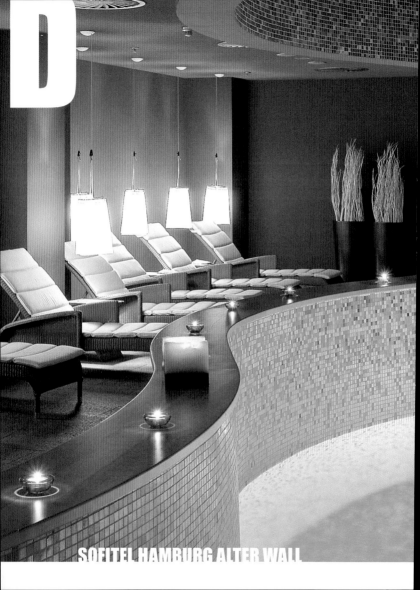

D

SOFITEL HAMBURG ALTER WALL

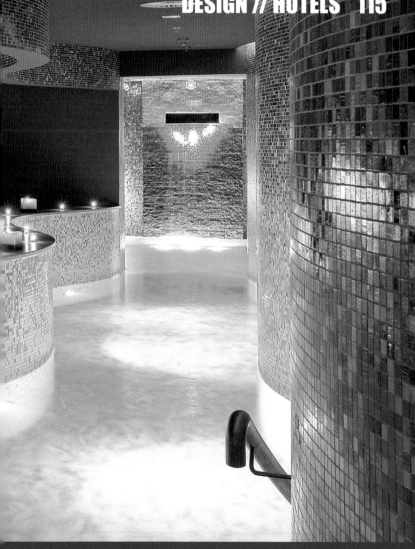

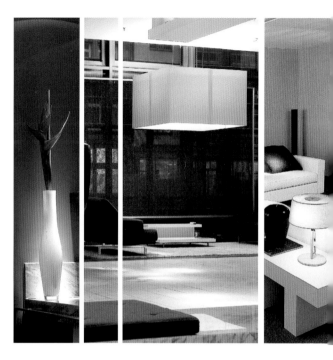

SOFITEL HAMBURG ALTER WALL

Alter Wall 40 // Altstadt
Tel.: +49 (0)40 36 95 00
www.sofitel.com

S1, S2, S3 Stadthausbrücke
U3 Rathaus

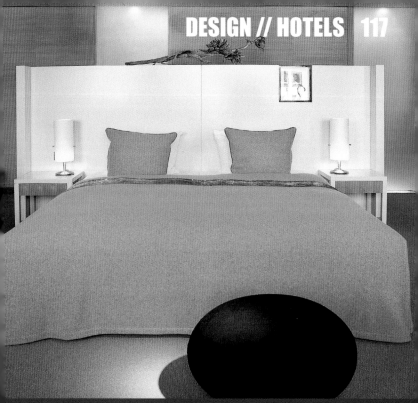

The interior designer Bert Haller, who is entrusted with large projects, designed the rooms of this hotel so they are clear, light, and elegant. Gray tones dominate the color scheme; light marble and warm light convey restrained luxury. In the unadorned building of the former Postbank, the eye finds peace. The spa area in the basement benefited from the fact that hardly any walls could be moved. The "canyon" that arose because of this snakes through a glamorous mosaic world.

Klar, hell und elegant gestaltete der mit großen Projekten vertraute Innenarchitekt Bert Haller die Räume des Hotels. Grautöne dominieren das Farbkonzept, heller Marmor und warmes Licht vermitteln zurückhaltenden Luxus. In dem schlichten Bau des ehemaligen Postbankgebäudes findet das Auge Ruhe. Dem Spa-Bereich im Untergeschoss kam die statische Situation zugute, in der kaum Wände versetzt werden konnten. Der entstandene „Canyon" schlängelt sich durch eine glamouröse Mosaik-Welt.

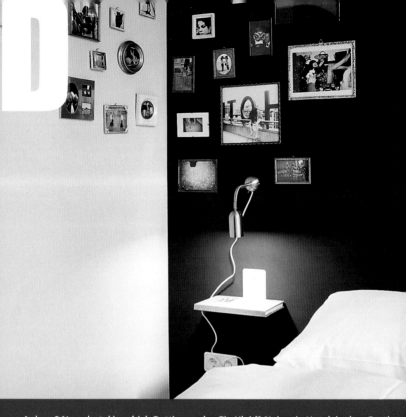

A dress? No, a hotel in which Bettina and Ralph Merz want to give their guests an understanding of their own weakness for photographic art—in an individual atmosphere. The costume designer and art director have dunked the rooms of this building in exciting colors and gone for interior clarity. The walls feature photos which are regularly replaced by others. The private viewings on these occasions open the hotel to visitors and turn it into a gallery.

Ein Kleid? Nein, ein Hotel, in dem Bettina und Ralph Merz den Gästen neben einer individuellen Atmosphäre auch ihr Faible für Fotokunst näherbringen möchten. Die Kostümbildnerin und der Art Director haben die Zimmer des Hauses in aufregende Farben getaucht, wobei sie beim Interieur auf Klarheit setzten. An den Wänden hängen Fotos, die regelmäßig ausgetauscht werden. Die zu diesem Anlass stattfindenden Vernissagen öffnen das Hotel für Besucher und lassen es zu einer Galerie werden.

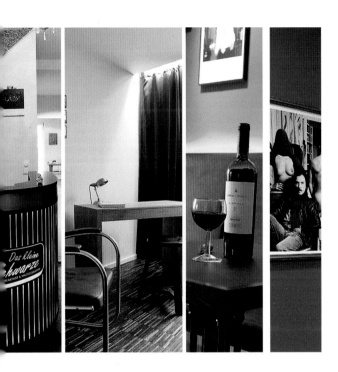

DAS KLEINE SCHWARZE

Tornquiststraße 25 // Eimsbüttel
Tel.: +49 (0)40 23 93 99 11
www.das-kleine-schwarze.com

U2 Emilienstraße

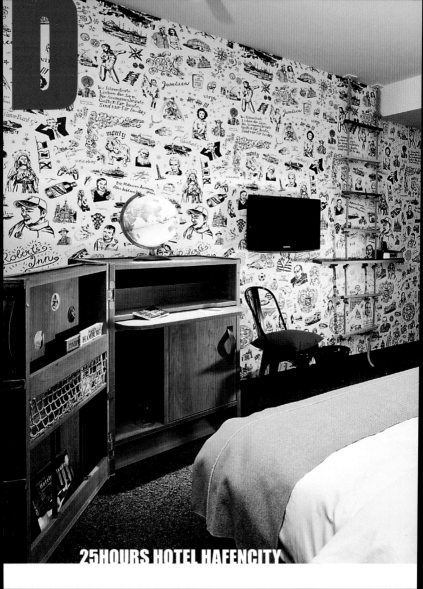

25HOURS HOTEL HAFENCITY

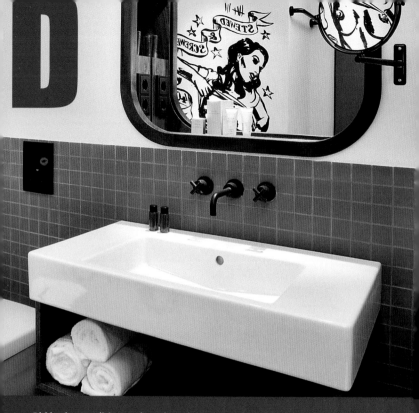

Old harbor tradition and modern design are combined here in wonderful fashion. The hotel's "guest berths" tell 25 real sailors' stories, illustrated with pictures and objects, about which guests can also read in "log books." There is a lot to discover in these comfortable rooms. The design of the first hotel to open in HafenCity demonstrates new Hamburg's humorous yet well-informed treatment of Hanseatic history.

Auf wunderbare Weise wird hier alte Hafentradition mit modernen Designideen kombiniert. Die sogenannten Gästekojen erzählen 25 reale Seemannsgeschichten, illustriert mit Bildern und Gegenständen, die der Gast auch in „Logbüchern" nachlesen kann. In den überaus gemütlichen Zimmern gibt es viel zu entdecken. Die Gestaltung des ersten Hotels, das in der HafenCity eröffnet hat, demonstriert den humorvollen, aber keineswegs ignoranten Umgang des jungen Hamburgs mit der hanseatischen Geschichte.

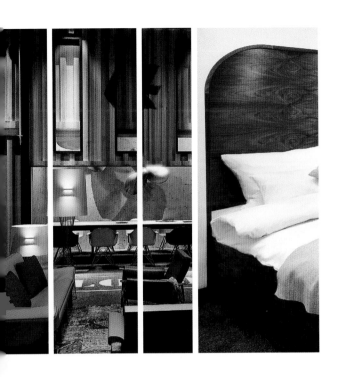

25HOURS HOTEL HAFENCITY

Überseeallee 5 // HafenCity
Tel.: +49 (0)40 2 57 77 70
www.25hours-hotels.com/hafencity

U1 Meßberg
U3 Baumwall

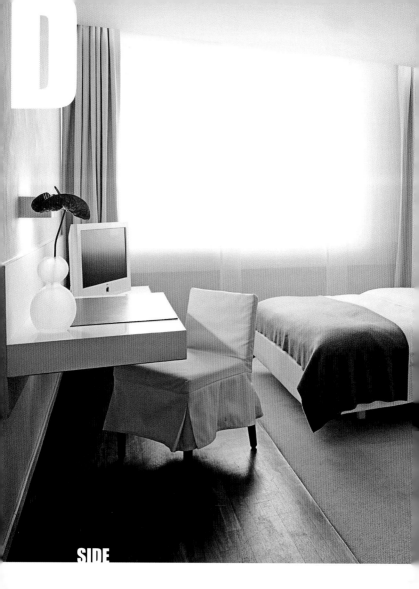

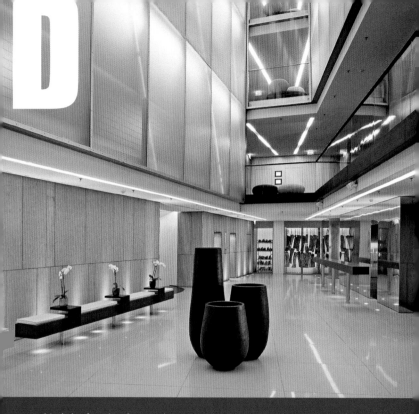

D

Behind the facade of natural stone and glass, there are rooms of puristic class. The Milan designer Matteo Thun created an elegant mix of various materials and colors, to which he added objects designed specifically for the hotel. The installation by the New York light choreographer Robert Wilson in the 80 ft. high atrium stimulates the senses and crowns the reserved formal language that was predetermined by the exterior, designed by Jan Störmer Architekten of Hamburg.

Hinter der Fassade aus Naturstein und Glas eröffnen sich Räume von puristischer Klasse. Der Mailänder Designer Matteo Thun kreierte einen eleganten Mix aus verschiedenen Materialien und Farben, den er mit eigens für das Hotel entworfenen Objekten ergänzte. Die Installation des New Yorker Lichtchoreografen Robert Wilson im 24 m hohen Atrium berührt die Sinne und setzt der zurückhaltenden Formensprache, die von den Hamburger Jan Störmer Architekten von außen vorgegeben wurde, die Krone auf.

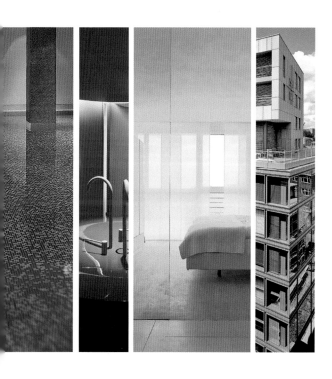

SIDE

Drehbahn 49 // Neustadt
Tel.: +49 (0)40 30 99 90
www.side-hamburg.de

U2 Gänsemarkt

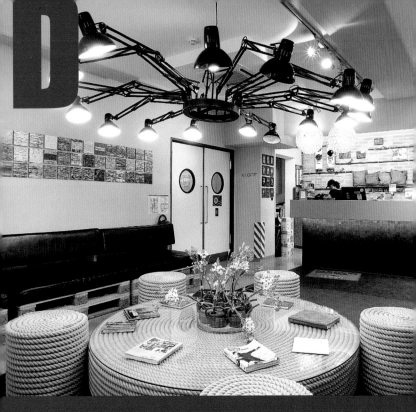

In this hostel, common household objects and everyday items are playfully repurposed and set into a cool design context. Armin Fischer's renowned agency Dreimeta has furnished the unconventional and offbeat house with beer crates, washing drums, and plumber's friends. All these objects became pieces of furniture without undergoing any radical changes. The design also pays tribute to the Hanseatic background—amongst others by employing beer crates of the local brand Astra.

Spielerisch sind hier triviale Alltagsgegenstände in einen Design-Kontext gestellt und einer neuen Funktion zugeführt. Die renommierte Agentur Dreimeta um Armin Fischer stattete das unkonventionelle Haus mit Bierkästen, Waschtrommeln und Saugglocken aus. Ohne die Objekte grundlegend zu verändern, wurden aus ihnen Möbel und Accessoires. Auch der hanseatische Kontext ist in dem außergewöhnlichen Gestaltungskonzept bedacht, deswegen sind z. B. die Bierkästen auch von Astra!

SUPERBUDE
HOTEL & HOSTEL & LOUNGE

Spaldingstraße 152 // St. Georg
Tel.: +49 (0)40 3 80 87 80
www.superbude.de

S1, S2, S11, S21, U2, U3 Berliner Tor

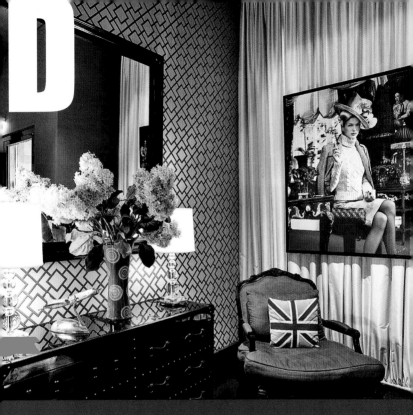

In this hotel, your stay is very British! A library with Chesterfield chairs, Eames rocking armchairs with Union Jack pillows, large-format pictures, extravagant wallpaper and carpets—this mixture of British tradition and modernity is the "New British Style." The experienced Hamburg hotelier Kai Hollmann decided on a design that seeks to consciously stand apart from contemporary reduction, thereby allowing extraordinary details.

In diesem Hotel logiert man very british! Eine Bibliothek mit Chesterfieldsesseln, Eames Rocking Armchairs mit Union Jack-Kissen, großformatige Bilder, extravagante Tapeten und Teppiche – diese Mischung aus britischer Tradition und Modernität ist der „New British Style". Damit entschied sich der erfahrene Hamburger Hotelier Kai Hollmann für ein Design-Konzept, das sich bewusst von zeitgenössischer Reduziert-heit abhebt und damit die Möglichkeit für außergewöhnliche Details schafft.

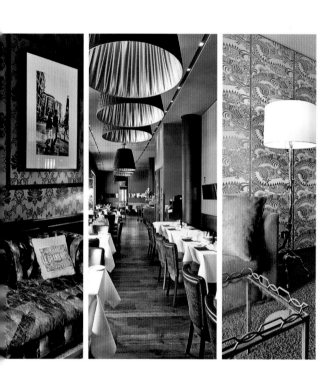

THE GEORGE

Barcastraße 3 // St. Georg
Tel.: +49 (0)40 2 80 03 00
www.thegeorge-hotel.de

U1 Lohmühlenstraße
Bus 6 Asklepios Klinik St. Georg

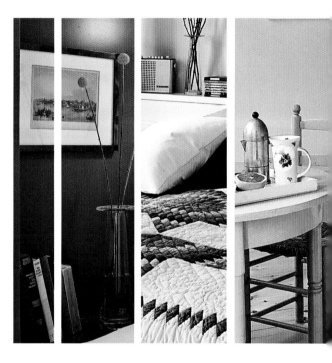

DAS FERIENHÄUSCHEN

Paul-Roosen-Straße 7a // St. Pauli
Tel.: +49 (0)170 7 35 08 50
www.dasferienhäuschen.de

S1, S2, S3 Reeperbahn
U3 St. Pauli

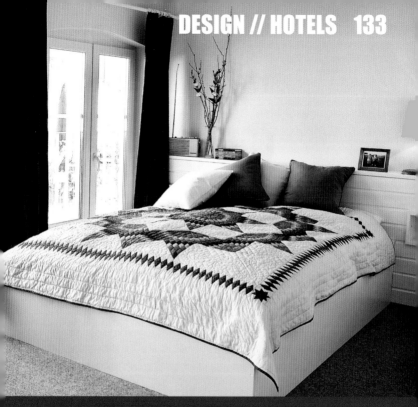

Romanticism comes alive in this charmingly-furnished 700 sq. ft. house. Hidden in a quiet back courtyard, the two-story house built at the turn of the 20th century offers space for up to six people. The rooms, designed in a kind of trendy country house style, are equipped with self-designed fixtures and individually-selected vintage accessories complemented by color accents on the walls. If guests venture out the door onto the street, they will find themselves right in the middle of lively St. Pauli.

In diesen charmant eingerichteten 64 m² kommt Romantik auf. Versteckt auf einem stillen Hinterhof, bietet das zweistöckige Häuschen aus der Jahrhundertwende bis zu sechs Personen Platz. Die Räume, in einer Art poppigem Landhausstil gestaltet, sind mit selbst entworfenen Einbauten und individuell ausgesuchten Vintage-Accessoires ausgestattet, die durch Farbakzente an den Wänden ergänzt werden. Tritt der Gast aus der Tür auf die Straße, empfängt ihn sofort die Lebendigkeit St. Paulis.

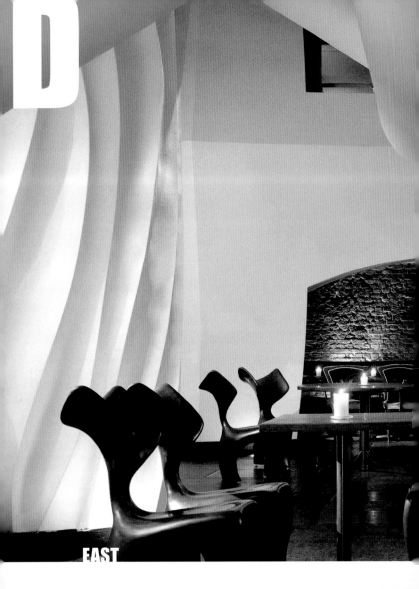

D

EAST

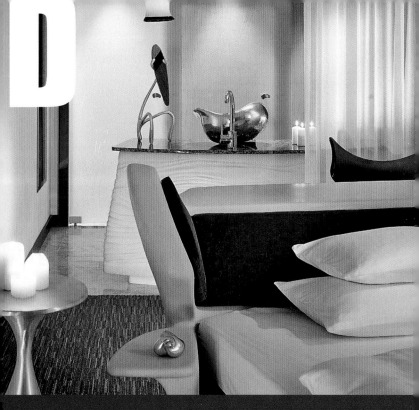

The steel and glass facade of this hotel, which opened in 2004, is open and clear amidst the red lights of St. Pauli. The brick building of a former iron foundry was gutted by the architects Schmitz-Mohr + Wölk & Partner and placed inside a contemporary, reduced shell. Inside the building, the American designer Jordan Mozer created a world of organic sensuality according to the principles of Feng Shui; round forms and fragrances play a large role here.

Offen und klar wirkt die Stahl-Glas-Fassade des im Jahr 2004 eröffneten Hotels inmitten der roten Lichter von St. Pauli. Der Klinkerbau einer ehemaligen Eisengießerei wurde von den Architekten Schmitz-Mohr + Wölk & Partner entkernt und in eine zeitgenössisch reduzierte Hülle gesteckt. Im Inneren des Gebäudes erschuf der amerikanische Designer Jordan Mozer nach den Prinzipien des Feng Shui eine Welt organischer Sinnlichkeit, in der runde Formen und Düfte eine große Rolle spielen.

EAST

Simon-von-Utrecht-Straße 31 // St. Pauli
Tel.: +49 (0)40 30 99 30
www.east-hamburg.de

S1, S2, S3 Reeperbahn
U3 St. Pauli

MÖVENPICK HOTEL HAMBURG

Sternschanze 6 // Sternschanze
Tel.: +49 (0)40 3 34 41 10
www.moevenpick-hamburg.com

S11, S21, S31, U3, Bus 181 Sternschanze

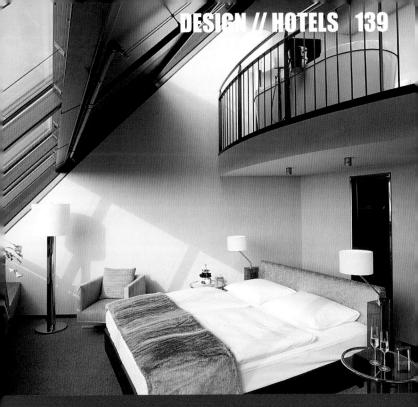

226 rooms and suites are arranged like slices of pie inside this historical water tower from the year 1910. The interplay of an historic structure with modern fixtures gives this Hamburg branch of the Swiss hotel chain Mövenpick a fascinating wealth of contrast. The lobby, located in an impressive brick vault once used as a reservoir, and the subterranean moving walkway that takes visitors to the four newly created atriums are among the highlights.

Wie Tortenstücke sind die 226 Zimmer und Suiten im historischen Wasserturm aus dem Jahr 1910 angeordnet. Die Hamburger Dependance der Schweizer Hotelkette wartet mit interessanten Kontrasten auf, die sich im Zusammenspiel der historischen Bausubstanz mit den modernen Einbauten ergeben. Highlights sind die Lobby im beeindruckenden Backsteingewölbe des ehemaligen Wasserspeichers oder das unterirdische Rollband, das in vier neu geschaffene Lichthöfe führt.

D

MOONDOO

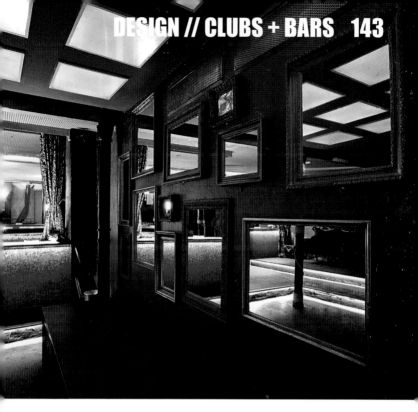

Syrian gilding covers the pillars, whose capitals open to the ceiling in the shape of a Eucalyptus bloom. Silk-covered pillows frame the pedestals of various height lit from below; these subdivide the floor of the main room and the streams of light from circular lampshades across the dance floor. The former Top Ten, where the Beatles appeared in 1961, now exudes the rich elegance of a boudoir whose rooms are filled with the sounds of current club music.

Syrisches Blattgold bedeckt die Säulen, deren Kapitelle sich in Form einer Eukalyptusblüte zur Decke öffnen. Samtbezogene Polster rahmen die unterschiedlich hohen, von unten beleuchteten Podeste ein, die den Boden des Hauptraumes unterteilen, und über der Tanzfläche strahlt das Licht aus kreisrunden Lampenschirmen. Das ehemalige Top Ten, in dem 1961 die Beatles auftraten, verbreitet heute die üppige Eleganz eines Boudoirs, dessen Räume von den Klängen aktueller Clubmusik erfüllt sind.

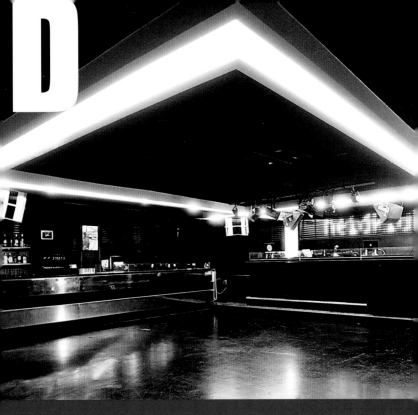

D

This club seems almost reticent among the opulent neon advertising of neighboring establishments on the Reeperbahn. Inside, it is clear why it needs no flashing lights on the exterior. More than 1,200 LEDs visually complement the excellent sound on the dance floor. Hip hop, house, and electro can be heard here. In the well-designed lounge area, the wall motif draws attention to itself with a light-flooded forest—as does the view of the neighborhood below from the window.

Zurückhaltend gibt sich der Club zwischen der opulenten Neonreklame benachbarter Etablissements auf der Reeperbahn. Innen wird klar, warum es außen nicht blinken muss. Über 1 200 LEDs sorgen im Tanzbereich für die visuelle Ergänzung des exzellenten Sounds. Hip Hop, House oder Elektro wird hier aufgelegt. Im gediegen gestalteten Loungebereich zieht das Wandmotiv eines lichtdurchfluteten Waldes die Blicke auf sich – oder aber die Sicht aus dem Fenster auf den Kiez.

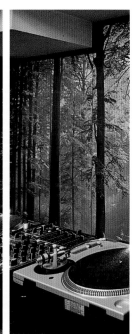

NEIDKLUB

Reeperbahn 25 // St. Pauli
Tel.: +49 (0)40 94 79 32 95
www.neidklub.de

Fri, Sat from 11 pm
S1, S2, S3 Reeperbahn
U3 St. Pauli

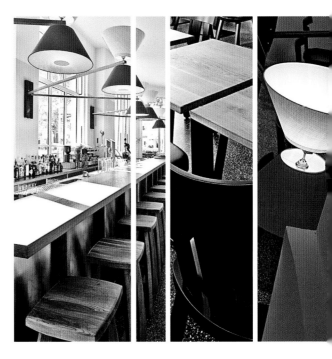

GORILLA GRILL

Eppendorfer Weg 58 // Eimsbüttel
Tel.: +49 (0)40 55 77 58 57
www.gorilla-grill.de

Mon–Fri from noon, Sat–Sun from 10 am
U2 Christuskirche

Coziness and modernity are united here in a new interpretation of the inn. The interior of this restaurant was designed by Sebastian Mends-Cole in a consciously simple but not Spartan fashion. Wooden furniture is combined with fabric napkins and fine silverware; extravagant lamps dominate the room and provide colorful emphasis. The conspicuous wall installation is by Thorsten Brinkmann and includes a veiled self-portrait, in the style that is typical for this artist.

Gemütlichkeit und Modernität vereinen sich hier zu einer Neuinterpretation des Wirtshauses. Das Interieur des Restaurants hat Designer Sebastian Mends-Cole bewusst einfach, doch nicht spartanisch gestaltet. Holzmobiliar wird mit Stoffservietten und edlem Besteck kombiniert, extravagante Lampen beherrschen den Raum und setzen farbige Akzente. Von Thorsten Brinkmann stammt die auffällige Wandinstallation mit einem verhüllten Selbstportrait im typischen Stil des Künstlers.

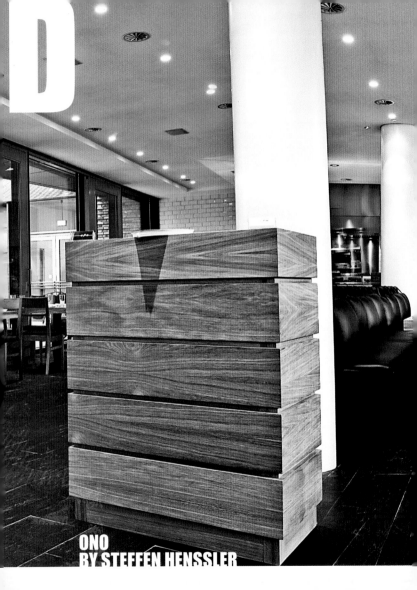

ONO
BY STEFFEN HENSSLER

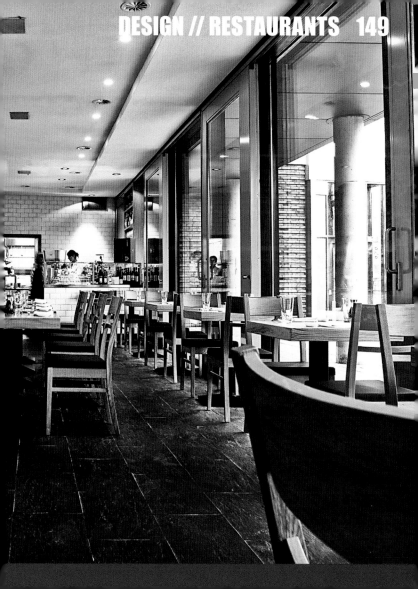

ONO
BY STEFFEN HENSSLER

Lehmweg 17 // Eppendorf
Tel.: +49 (0)40 88 17 18 42
www.onobysh.de

Mon–Sat noon to 3 pm and 6 pm to 11 pm
U1 Klosterstern
U3 Hoheluftbrücke

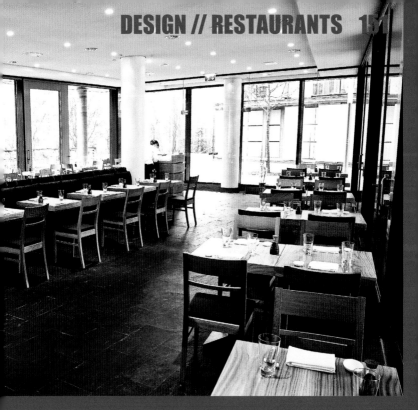

The second restaurant of TV chef Steffen Henssler not only has an excellent view of the Isebek Canal, but also has an impressive Asian-inspired interior. A place of sensory enjoyment has been created with wood and glass, dominated by a black-and-white ambience and a focus on the essential—the food. For in the end, the restaurant's appearance is its garnish: sushi and fresh fish are draped like little works of art on wooden boards and plates.

Das zweite Restaurant von Fernsehkoch Steffen Henssler beeindruckt nicht nur mit dem freien Blick auf den Isebek-kanal, sondern auch durch sein asiatisch inspiriertes Interieur. Mit Holz und Glas wird in schwarz-weiß dominiertem Ambiente ein Ort sinnlichen Genießens mit der Konzentration auf das Wesentliche geschaffen – die Speisen. Deren Erscheinen krönt schließlich das Bild: Sushi und frischer Fisch sind wie kleine Kunstwerke auf Holzbrettchen und Tellern drapiert.

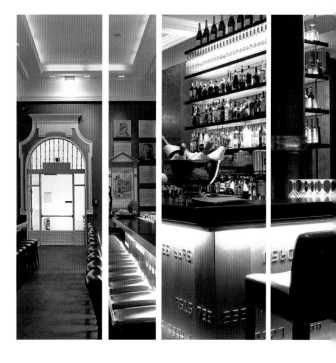

DIE BANK

Hohe Bleichen 17 // Neustadt
Tel.: +49 (0)40 2 38 00 30
www.diebank-brasserie.de

Daily 11.30 am to 11 pm
Bar open till 2 am
U2 Gänsemarkt

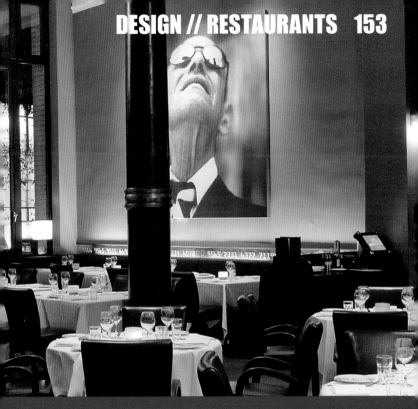

A high plaster ceiling borne by pillars, sophisticated glass crystal lights, dark wood and leather—the interior of the restaurant is a fine example of classic elegance. Even if the building erected in 1897 by Wilhelm Martens for the Hypothekenbank has been modernized and renovated, the flair of the turn of the century and the 1920s has been retained in its rooms. Numerous inventive details and pictures pay tribute to good old money.

Eine hohe, von Säulen getragene Stuckdecke, mondäne Glaskristall-Leuchter, dunkles Holz und Leder – das Interieur des Restaurants ist ein Musterbeispiel an klassischer Eleganz. Auch wenn das 1897 von Wilhelm Martens für die Hypothekenbank errichtete Gebäude inzwischen modernisiert und umgebaut wurde, scheint das Flair der Jahrhundertwende und der bald folgenden, glamourösen 20er Jahre in den Räumen erhalten geblieben zu sein. Das liebe Geld wird auf Bildern und mit zahlreichen, originellen Details geehrt.

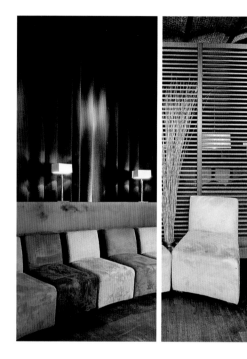

RIVER KASEMATTEN

St. Pauli Fischmarkt 28-32 // St. Pauli
Tel.: +49 (0)40 30 06 01 90
www.river-kasematten.de

Open 24 hours
S1, S2, S3 Reeperbahn

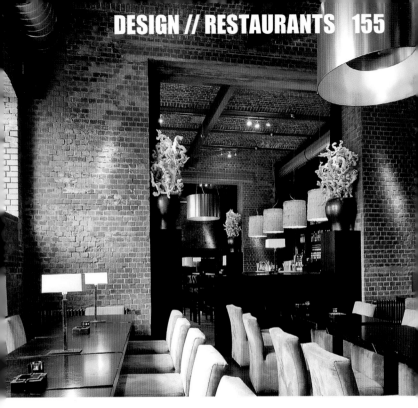

Built in 1865 as a market tunnel, in the decades which followed the building was used for various purposes, e.g. as a jazz club in the 1960s. Today, there is space for 300 people in the long rooms with a restaurant, bar, and lounge area. The dark furnishings are sophisticated; golden lamps covered with feathers, plush chairs, and fine wooden furniture are complemented by a terrace with harbor view. In the lounge area with a fireplace, DJs play the adequate music.

1865 als Markttunnel erbaut, wurde das Gebäude in den folgenden Jahrzehnten unterschiedlich genutzt, z. B. als Jazzclub in den 60er Jahren. Heute finden 300 Personen in den langgestreckten Räumen mit Restaurant, Bar und Loungebereich Platz. Die dunkel gehaltene Einrichtung gibt sich mondän; goldene und mit Federn bedeckte Lampen, gepolsterte Stühle und edles Holzmobiliar werden von einer Terrasse mit Hafenblick ergänzt. Im Loungebereich mit Kamin legen DJs die passende Musik auf.

The Hamburg branch opened in 1996 as the first of four design department stores in various German and Austrian cities. In the century-old building of a former malt factory, there are 28 shops grouped in galleries on five stories around the glass-roofed atrium. These shops offer only internationally-renowned top furnishing and design brands, such as B&B Italia and Cassina, but also a selection of classics by Walter Knoll and Vitra, amongst others.

Die Hamburger Dependance wurde 1996 als erstes von inzwischen vier Designkaufhäusern in verschiedenen Städten eröffnet. In dem über 100 Jahre alten Gebäude einer ehemaligen Malzfabrik befinden sich 28 Shops, die sich in Galerien auf fünf Etagen um das glasüberdachte Atrium gruppieren. Die Läden bieten ausschließlich international renommierte Spitzenmarken aus Einrichtung und Wohndesign an, wie B&B Italia oder Cassina, aber auch Klassiker von Walter Knoll und Vitra.

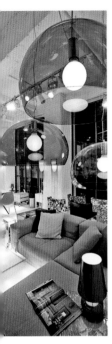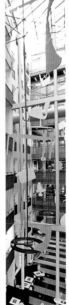

STILWERK

Große Elbstraße 68 // Altona-Altstadt
Tel.: +49 (0)40 30 62 11 00
www.stilwerk.de

Mon–Fri 10 am to 7 pm
Sat 10 am to 6 pm
S1, S2, S3 Königstraße

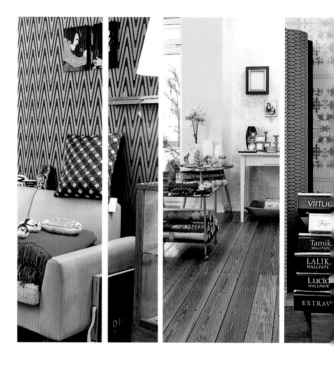

PERLE

Weidenallee 23 // Eimsbüttel
Tel.: +49 (0)40 28 78 12 28
www.perle-shop.de

Tue–Fri 11 am to 7 pm
Sat 11 am to 4 pm
S11, S21, S31, U3 Sternschanze
U2 Christuskirche

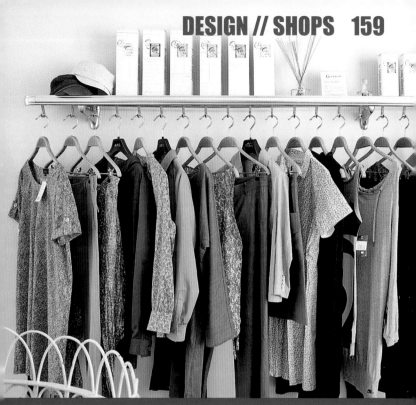

For a long time, raw fibers characterized the walls of German living rooms; now luscious colors and refined patterns are coming back. This shop offers exclusive wallpapers by various designers as well as expert advice on design. Exquisite items for other areas of life are also on offer: reworked vintage lamps by Mona Moore, jewelry by Arena Copenhagen, and fashion by the Paris label A.P.C. feature in the stylish product range.

Lange Zeit hat die Raufaser das Wand-design deutscher Wohnzimmer bestimmt, nun kehren satte Farben und raffinierte Muster zurück. Der Shop bietet exklusive Tapeten verschiedener Designer sowie eine kompetente Beratung in Gestal-tungsfragen. Auch für andere Bereiche des Lebens wird Erlesenes unterbreitet: Aufgearbeitete Vintage-Lampen von Mona Moore, Schmuck von Arena Copenhagen oder Mode des Pariser Labels A.P.C. sind Bestandteile des stilsicher zusammenge-stellten Sortiments.

MOST THINGS LOOK BETTER WHEN YOU COLOUR THEM

GUDBERG

In the year 2000, the prize-winning and ambitious graphic designer Jan Mueller-Wiefel assembled a team in order to establish the name GUDBERG as a brand for stylish layout, design, and publishing. The inspiring gallery shop associated with the design office sells prints and publications. The picture books, books, and artzines on the shelves are a treat for the eyes, and make you want to take them home.

Preisdotiert und ambitioniert versammelte Grafik-Designer Jan Mueller-Wiefel im Jahr 2000 ein Team um sich, um den Namen GUDBERG als Markenzeichen für treffsicheres Layouten, Gestalten und Verlegen zu etablieren. Der dem Design-Büro zugehörige Galerie-Shop bietet in einer inspirierenden Umgebung Prints und Publikationen zum Kauf an. Die Bildbände, Bücher und Artzines in den Regalen sind wie Süßigkeiten für die Augen, die man am liebsten alle gleich mit nach Hause nehmen möchte.

GALERIA GUDBERG

Poolstraße 8 // Neustadt
Tel.: +49 (0)40 8 19 51 50
www.gudberg.de

Mon–Fri 10 am to 6 pm
U2 Gänsemarkt

MAYGREEN

Große Rainstraße 17 // Ottensen
Tel.: +49 (0)40 39 10 99 00
www.maygreen.de

Mon–Fri 11 am to 7 pm
Sat 11 am to 5 pm
S1, S2, S3, S11, S31 Altona

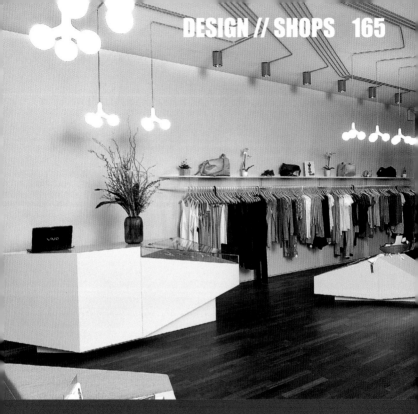

The philosophy here has percolated right down to the last detail of the design of the interior. The fixtures are like futuristic sculptures; the light installation on the ceiling becomes a visual focus due to its graphically-arranged surface-mounted cabling, and the color green provides emphasis. The product range only includes fashion labels produced in an ecologically-sustainable manner. Selected pieces by Filippa K and iheart help customers become part of a modern, ecologically-aware future.

Bis ins letzte Detail wurde hier die Philosophie in das Interiordesign übersetzt. Die Ladeneinbauten gleichen futuristischen Skulpturen, die Lichtinstallation an der Decke wird durch eine grafisch angeordnete Überputzverkabelung zum Blickfang und die Farbe Grün setzt Akzente. Zum Sortiment gehören ausschließlich Modelabels, die ökologisch nachhaltig produzieren. Ausgesuchte Stücke von Filippa K oder iheart lassen die Kundinnen Teil einer modernen, ökologisch bewussten Zukunft werden.

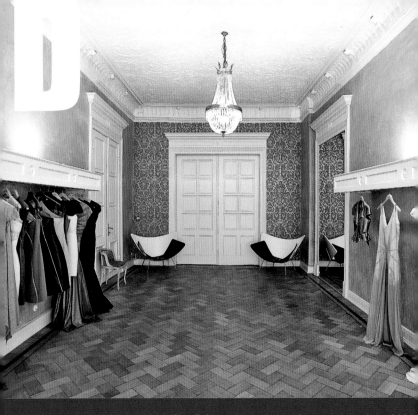

This young designer consciously calls his store, opened in 2009 on the elegant Hamburg Mittelweg, a "salon." Inspired by the charm of French couture houses of the 1950s, this perfectionist designed the fixtures himself. The white-painted wood with finely-chiseled details is everywhere, even on the sophisticated desk in the attached atelier. Between the parquet floors and ceiling sprinkled with floral plastering, his clothes seem to float on the hangers in the room.

Der junge Designer nennt seinen 2009 eröffneten Laden im noblen Hamburger Mittelweg bewusst „Salon". Inspiriert vom Charme französischer Couture-Häuser der 50er Jahre entwarf der Perfektionist die Einbauten selbst. Überall findet sich das weiß lackierte Holz mit den fein ziselierten Details wieder, auch an dem mondänen Arbeitspult im angeschlossenen Atelier. Zwischen Parkett und prächtiger, mit floralem Stuck übersäter Decke scheinen seine Kleider an den Bügeln im Raum zu schweben.

STEFAN ECKERT

Mittelweg 19 // Rotherbaum
Tel.: +49 (0)40 63 70 89 15
www.stefaneckertdesign.com

Mon–Fri 11 am to 7 pm
Sat 11 am to 4 pm
U1 Hallerstraße

STEFAN
ECKE

RT

The young German fashion designer Stefan Eckert cuts an imposing figure. He had parts of the tattoo that covers his left arm done when he was 19 years old; from that time on, his path as an artist was clear. His training encompassed stints with Alexander McQueen and the Central Saint Martins College in London, which saw Eckert experience fashion handiwork on a high level from the very start. He selected Hamburg consciously, choosing to open his showroom in the Hanseatic city, because here, he believes, there is an affinity for quality and consistency, which are the ideal prerequisites for his work. A well-heeled clientele gives him the opportunity to realize his artistic ideas and to present them spectacularly, no holds barred.

Stefan Eckert is a man with vision and a clear image of women; this is why his avant-garde yet wearable fashion is not made for underweight fashion dolls, but for self-aware Amazons.

Der junge deutsche Modedesigner Stefan Eckert ist eine imposante Erscheinung. Teile des Tattoos, das seinen linken Arm bedeckt, ließ er sich bereits mit 19 Jahren stechen, ab diesem Zeitpunkt war für ihn der Weg als Künstler klar gezeichnet. Durch die Stationen seiner Ausbildung bei Alexander McQueen und dem Central Saint Martins College in London erlebte Eckert Modehandwerk von Anfang an auf einem hohen Niveau. Mit der Eröffnung seines Showrooms in Hamburg entschied er sich bewusst für die Hansestadt, in der er eine Affinität zu Qualität und Beständigkeit als ideale Voraussetzung für seine Arbeit sieht. Eine finanzstarke Klientel gibt ihm die Möglichkeit, künstlerische Ideen für seine Kreationen und für deren spektakuläre Präsentation ohne Kompromisse umzusetzen.

Stefan Eckert ist ein Mann mit Visionen und einem klaren Frauenbild, deswegen ist seine avantgardistische, aber dennoch tragbare Mode nicht für untergewichtige Modepüppchen, sondern für selbstbewusste Amazonen gemacht.

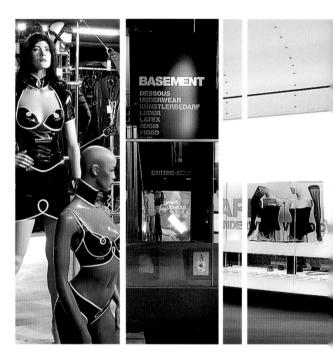

BOUTIQUE BIZARRE

Reeperbahn 35 // St. Pauli
Tel.: +49 (0)40 31 76 96 93
www.boutique-bizarre.de

Daily 10 am to 2 am
S1, S2, S3 Reeperbahn
U3 St. Pauli

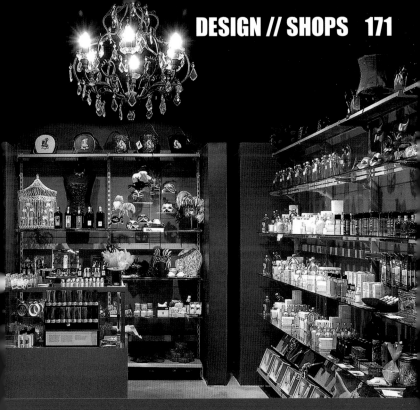

On the Reeperbahn, the most famous red-light district in Germany, this stylish erotic megastore offers frivolous goods in an elegantly sparse environment. A tour through the two stories of departments of diverse design with a sales space of nearly 15,000 sq. ft. feels almost like a museum visit. The gallery associated with the store, which is in the basement, features changing exhibits of erotic paintings, graphic art, and photographs by different artists.

Auf der Reeperbahn, der bekanntesten Rotlichtmeile Deutschlands, bietet dieser durchgestylte Erotik-Megastore frivole Waren in einer elegant reduzierten Umgebung an. Ein Rundgang durch die unterschiedlich designten Abteilungen auf zwei Etagen, mit einer Verkaufsfläche von insgesamt 1 400 m², fühlt sich fast ein wenig museal an. Die dem Laden zugehörige Galerie im Untergeschoss zeigt in wechselnden Ausstellungen erotische Gemälde, Grafiken und Fotografien verschiedener Künstler.

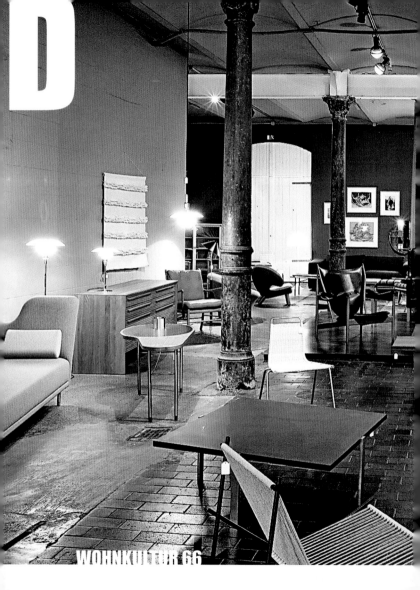

D

WOHNKULTUR 66

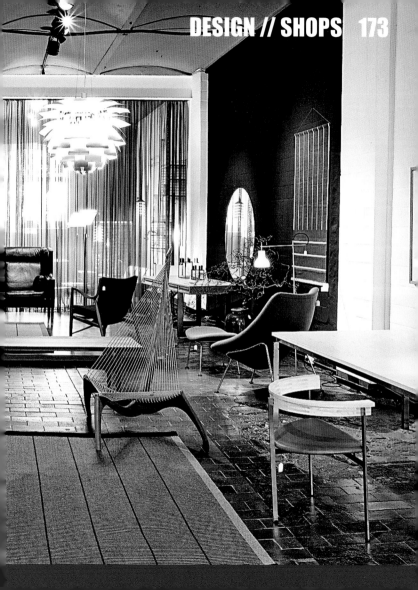

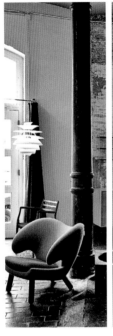

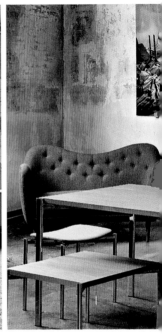

WOHNKULTUR 66

Sternstraße 66 // Sternschanze
Tel.: +49 (0)40 43 60 02
www.wohnkultur66.de

Tue–Sat noon to 6 pm
U3 Feldstraße

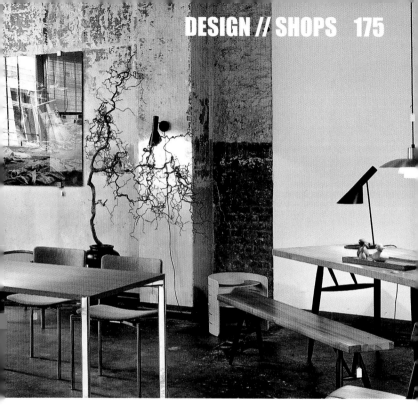

Scandinavian design has been drawing increased international attention for some time. In addition to fashion, there is also furniture, whose understatement seems to suit the tastes of the times—and this is precisely what Martina Münch and Manfred Werner specialize in. They offer mostly manufactured goods from various Scandinavian furniture designers, including pieces by Alvar Aalto and Poul Kjaerholm, as well as Finn Juhl, whom they represent exclusively in Germany.

Skandinavisches Design erfreut sich seit einigen Jahren verstärkt internationaler Aufmerksamkeit. Neben Mode sind es auch Möbel, die mit reduziertem Understatement den Geschmack der Zeit zu treffen scheinen – und genau darauf haben sich Martina Münch und Manfred Werner spezialisiert. Sie bieten überwiegend Manufakturware verschiedener skandinavischer Möbeldesigner an, darunter Stücke von Alvar Aalto oder Poul Kjaerholm sowie von Finn Juhl, den sie in Deutschland exklusiv vertreiben.

The three stories of this former industrial-scale laundry seem hardly sufficient to accommodate the vast selection of lifestyle products that await their buyers here. Unique collections are developed in cooperation with various renowned cushion producers from Europe to add in-house fabrications to the shop's range of products. The associated restaurant Soul Flavor invites visitors to take a break from the world of design and focus on a wholly different kind of taste—that of meals and drinks.

Die drei Stockwerke der ehemaligen Groß-wäscherei scheinen kaum für das riesige Angebot an Lifestyle-Produkten auszurei-chen, das hier auf seine Käufer wartet. In Zusammenarbeit mit verschiedenen namhaften Polsterherstellern aus Europa werden eigene Möbelkollektionen entworfen, die das Sortiment um hauseigene Produkte ergänzen. Beim Verweilen im Restaurant Soul Flavour hat das Design Sendepause: Hier geht es um einen anderen Geschmack, nämlich den der Speisen und Getränke.

DIE WÄSCHEREI

Jarrestraße 58 // Winterhude
Tel.: +49 (0)40 2 71 50 70
www.die-waescherei.info

Mon–Sat 10 am to 8 pm
U3 Saarlandstraße

ART

ARCHITECTURE

MAP 179

ALTSTADT

Large, imposing buildings characterize the center of Hamburg, while the bridges and canals are the highlight of the luxury shopping area around the Jungfernstieg.

EPPENDORF

Between chic boutiques and restaurants, the old-established Hanseatic wealth resides here and amuses itself on the commercial street Eppendorfer Baum during leisure-time.

HAFENCITY

During a walk through the large, newly constructed area between the harbor and the Speicherstadt, green spaces, stores, and restaurants invite you to stay a while.

DESIGN

NEUSTADT

The urban mix of stores, cafés, and small agencies fills the streets with a casual lifestyle. The Portuguese quarter promises good international cuisine.

SCHANZENVIERTEL

This quarter, once occupied by squatters, is a hip area today, into which increasing amounts of capital are flowing. Creative types and students live here among galleries and bars.

ST. GEORG

The heart of the beloved gay quarter beats in the Lange Reihe, a street with many cafés and delis which is directly adjacent to the large art museums.

ST. PAULI

In this trendy neighborhood, an old harbor quarter, things are never quiet; the noise of the Reeperbahn with its clubs and bars seems to drown out everything else.

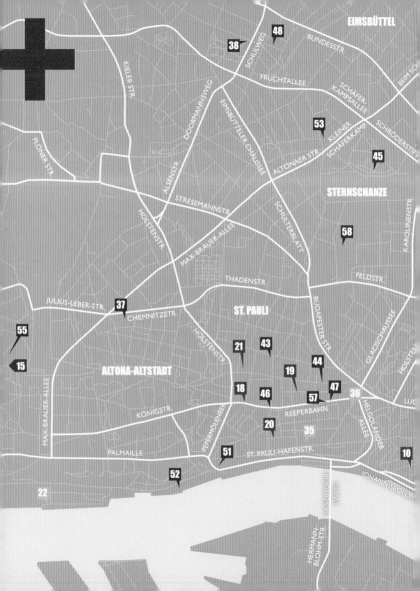

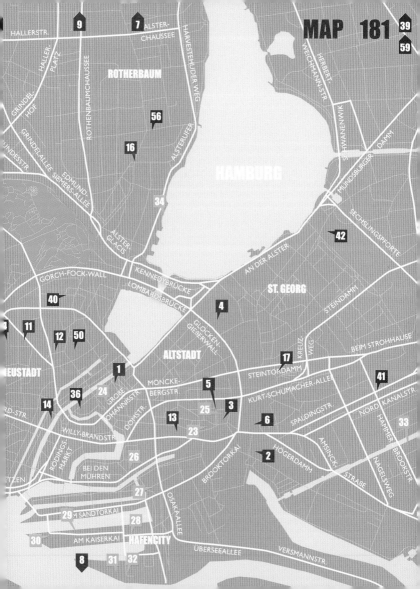

EMERGENCY

| Ambulance/Fire | 112 |
| Police | 110 |

ARRIVAL

BY PLANE: HAMBURG AIRPORT
centrally located in the city district Fuhlsbüttel
national and international flights
Tel.: +49 (0)40 5 07 50
www.airport.de
website also in English and Danish
public transportation:
S1 to station Hamburg Airport (Flughafen),
goes every 10 min.
2 min. walk from station to terminals
busses from city directly to terminals:
26, 292, 274, 606 (night bus), 39 (express)

BY TRAIN: HAMBURG HAUPTBAHNHOF
(Hamburg Central Station)
located in the city center, district St. Georg
Tel.: +49 (0)40 39 18 10 53
website with opening times and more:
www.wandelhalle-hamburg.de
Deutsche Bahn provides information about
all major train stations in Germany:
www.bahnhof.de
official timetables: **www.bahn.de**
website also in English
public transportation:
S1, S2, S3, U1, U2, U3 to and from station
Hauptbahnhof

GETTING AROUND

TAXI
Autoruf: +49 (0)40 44 10 11
Taxi Hamburg: +49 (0)40 66 66 66
Das Taxi: +49 (0)40 22 11 22
Hansa Taxi: +49 (0)40 211 211,
+49 (0)40 31 13 11
Hansa-Eco-Taxi: +49 (0)40 21 12 55
(no additional costs)

PUBLIC TRANSPORTATION
timetables and trip planner: **www.hvv.de**
Tel.: +49 (0)40 1 94 49

BICYCLE RENTAL
Hamburg City Cycles
Bernhard-Nocht-Straße 89-91, St. Pauli
Tel.: +49 (0)40 21 79 66 21
Cell: +49 (0)176 64 33 06 23
www.hhcitycycles.de
website also in English
bike rental near Reeperbahn; bike tours to
the harbor and more

Fahrradstation Dammtor
Schlüterstraße 11, Rotherbaum
Tel.: +49 (0)40 41 46 82 77
www.fahrradstation-hh.de
website only in German
Bike Tour Guide for free download
bike rental near Außenalster, various kinds
of bikes

Hamburg anders erfahren!
www.hamburg-anders-erfahren.de

experience Hamburg in a new way
website also in English
Cell: +49 (0)178 6 40 18 00
various kinds of bikes for rent; bike will be
delivered; guided bike and canoe tours

CAR RENTAL

Besides the recommendable international
car rentals there are some local companies
with favorable offers:

easyRent Tel.: +49 (0)40 5 30 03 53
www.easyrent-autovermietung.de

Profi-Rent Tel.: +49 (0)40 77 66 55
www.profirent.de

ACCOMODATION

www.hamburg-tourism.de
multilingual website with search engine for
hotels and rooms
www.hrs.de
budget offers for many accomodations
website in various languages
www.clipper-hotels.de
website also in English
Clipper Elb Lodge
well-designed boardinghouses

TOURIST INFORMATION

www.hamburg-tourism.de
Hamburg Sales & Service Center

Tel.: +49 (0)40 30 05 13 00
Mon–Sat 9 am to 7 pm

Hamburg Information at Hauptbahnhof
(Central Station)
Mon–Sat 9 am to 7 pm, Sun 10 am to 6 pm

Tourist Information Airport Office at Airport
Plaza between terminal 1 and 2
open daily 6 am to 11 pm

Tourist Information am Hafen (at harbor),
St. Pauli Landungsbrücken, between bridge
4 and 5
Sun–Wed 9 am to 6 pm
Sat 9 am to 7 pm

www.hamburg.de
official city website with news, information,
and lots of tips
also in English

www.hamburg-magazin.de
information about tours, festivals, recom-
mended sights, and more

CITY TOURS

BUS TOURS

An individual way to explore the city by bus
for less then 3 € is to take bus 112. The driv-
ers are used to tourists and answer questions
or make a short stop for photos.
The line passes by several sights such as
Reeperbahn, Fischmarkt, and harbor.

Find out about stops here: **www.hvv.de**
Tel.: +49 (0)40 1 94 49

At "Die Hamburg Cruiser" you can rent a small or big bus that picks you up wherever you are and whenever you want. The sightseeing tours feature live commentary in any language you wish.
Check out multilingual webpage for more information:
www.die-hamburg-cruiser.de

Jasper offers the "ArchitecTour" which shows and explains old and new architectural highlights of the city. Many buildings can be viewed from inside.
Start: Bus-Port Hamburg near Hauptbahnhof
online booking: **www.jasper.de**
Tel.: +49 (0)40 22 71 06 10

BOAT TOURS
HARBOR TOURS
Maritime Touren
5-hour harbor tour with lunch and many interesting stops and stories, start at St. Pauli Landungsbrücken, tickets 55 €
shorter tours are offered as well
www.maritime-touren.de

ABC-Barkassen
offers tours with "Barkassen," i.e. small boats. Short harbor tours to Hamburger Docks, HafenCity, and Speicherstadt
start at St. Pauli Landungsbrücken 4-5
Tel.: +49 (0)40 31 02 88

Kapitän Brüsse
Barkassen tours, boats have heaters and bathrooms; harbor tours and special offers, including a tour through Speicherstadt at sunset for 1.5 hours
all tours start at St. Pauli Landungsbrücken 3
Tel.: +49 (0)40 31 31 30

ALSTER TOURS
ATA Alster-Touristik
city round trip on Alster
audio guides in many languages
various tours are offered
starts daily at Altstadt, Jungfernstieg
Tel.: +49 (0)40 3 57 42 40

GUIDED TOURS
HafenCity tour "Der Landgang"
tour shows the exciting new district
starts at HafenCity InfoCenter at Kesselhaus, Am Sandtorkai 30, HafenCity
free of charge
Sat 3 pm
Tel.: +49 (0)40 3 74 72 60
www.hafencity.de

Elbphilharmonie Tour
Exciting tour across the construction site of the impressing Elbphilharmonie. Tours are in great demand, registration should be made in advance
Sun every 45 min.
duration of tour 90 min.
www.elbphilharmonie.de

Landgang St. Pauli
individual insider tours with date of choice
and topic of choice: culture, music, urban
development, and more
minimum 2 participants
tours also in English
for all offers check website
www.stpauli-landgang.de
Tel.: +49 (0)40 31 79 49 34

Olivias Safari
popular drag queen Olivia Jones gives an
entertaining tour of the Reeperbahn that
ends with a drink in one of her bars
Thu 8 pm, Fri–Sat 7 pm, 9 pm
starts at station U3 St. Pauli, exit Reeperbahn
more tour offers on website
www.olivia-jones.de

Hurentour
a very popular tour covering many centuries
of prostitution
starts at Davidwache (police station) at the
Reeperbahn
Thu–Sat from 8 pm to 10 pm
special appointments possible
www.hurentour.de

Hempel's Beatles Tour
guide Stefanie Hempel follows the tracks
of The Beatles in St. Pauli, in between she
sings Beatles songs with you
www.hempels-musictour.com
website also in English

TICKETS

Funke Konzertkassen
ticket agency at Hauptbahnhof
Hachmannplatz 10, St. Georg
Tel.: +49 (0)40 41 62 00 99
www.funke-ticket.de

Hamburg-Ticket
tickets for concerts and events in Hamburg
Tel.: +49 (0)40 68 85 55
www.hamburg-ticket.de

Hamburg Tourismus
a collection of recommended events
www.hamburg.de/tickets
website also in English

ART & CULTURE

Kunstecho Hamburg
independent gallery calendar
art exhibitions, vernissages, and events
www.kunstecho-hamburg.de

Galerien in Hamburg
a fine selection of galleries with descriptions
and pictures of current exhibitions
www.galerien-in-hamburg.de

Gängeviertel
area occupied by artists; website informs
about concerts, exhibitions, and readings
www.das-gaengeviertel.info

Laeiszhalle
renowned classical concert hall
the city's greatest symphony orchestras
play here: Philharmoniker Hamburg, NDR
Sinfonieorchester, Hamburger Symphoniker
www.elbphilharmonie.de/events
website also in English

Thalia Theater
well-known theater
renowned actors and directors
classical and progressive productions
Alstertor 1, Altstadt
Tel.: +49 (0)40 32 81 44 44

EVENTS

MUSIC
blurred edges
festival for contemporary music
many artists from Hamburg and elsewhere
www.blurrededges.de

Hamburger Klangwerktage
international offspring festival for contem-
porary music
the performers are renowned composers of
classical avant-garde and newcomers
find out about date, program, and tickets:
www.klangwerktage.de

klub katarakt
innovative festival for contemporary and elec-
tronic music, video, art, literature, and more
www.klubkatarakt.net

MS Dockville
music festival featuring the stars of interna-
tional club culture
3 days in the middle of August
includes an art camp with club- and media-
influenced works
Reiherstieg Hauptdeich/Alte Schleuse, Wil-
helmsburg
tickets, date, and line-up:
www.msdockville.de

Hamburger Straßenfeste
street festivals, city events, Sunday sales,
and more:
www.hamburg.de/strassenfest

AMUSEMENT PARK
Hamburger Dom
the biggest amusement park in Northern
Germany with historical roots
Heiligengeistfeld, Karolinenviertel
open 3 seasons
dates and more information:
www.hamburger-dom.de
website also in English

JUBILEE
Hafengeburtstag
very popular harbor birthday party
every year, 3 days in May
parades, boat races, stunt flying, live music,
food, and more
www.hamburg.de/hafengeburtstag
website also in English

FASHION

Kleidkunst
temporary young fashion events
www.kleidkunst.de
website also in English

DESIGN

designxport
Hamburg design network
www.designxport.de

FILM

Internationales Kurzfilmfestival Hamburg
international short film festival
7 days in spring
exact date, program, tickets, and more:
festival.shortfilm.com
website also in English

AWARD

LeadAwards Exhibition
temporary exhibition of candidates for one of
the most important print- and online media-
awards in Germany
Haus der Photografie Deichtorhallen
www.leadacademy.de

FAIRS

goodgoods
sustainable consumer goods show
interesting concepts and products by vari-
ous branches
www.goodgoods.de
website also in English

hanseboot
Oct 29 – Nov 6, daily 10 am to 6 pm
Wed 10 am to 8 pm
international boat exhibition
new products and world premiers

hanseboot ancora boat show
Germany's biggest in-water boat show
date may vary
www.hanseboot.de
website also in English

SPORTS

Deutsches Spring- und Dressur-Derby
international derby with showjumping and
dressage competition
Derbyplatz Klein-Flottbek, Nienstedten
takes place in spring
check website for date:
www.engarde.de/events

GOING OUT

Prinz
parties, concerts, culture, and more
www.hamburg.prinz.de

Oxmox
insider city magazine with tips and recom-
mendations
www.oxmoxhh.de

the official city website also has a detailed
nightlife section
www.hamburg.de/nachtleben-party

Cover photo (Dockland)
by David Burghardt (further credited as db)

Backcover by Rüdiger Glatz, Roland Halbe, db

ART
p 8–11 (Bucerius Kunst Forum) p 8–9, 10 middle left
and 11 photos by Ulrich Perrey, p 10 left courtesy
of Bucerius Kunst Forum, p 10 middle right photo
by Jörg Tietje (further credited as jt);
p 12–13 (Deichtorhallen Hamburg) p 12 and 13
right photos by db, all others by jt;
p 14–15 (Galerie PopArtPirat) p 14 art by Anna
Fiegen, p 15 middle art by Marc Podawczyk, all
photos courtesy of Galerie PopArtPirat;
p 16–19 (Hamburger Kunsthalle) p 16–17 art by
Roni Horn, p 19 left art by Tobias Rehberger, all
photos by db;
p 20–21 (Kramer Fine Art) art by Silke Silkeborg,
all photos by db;
p 22–25 (Kunstverein Hamburg) all photos by Fred
Dott, Hamburg;
p 26–27 (Galerie VERA MUNRO) art by Günther Förg
(p 26 and 27 left) and Silvia Bächli (p 27 middle), all
photos courtesy of Galerie VERA MUNRO;
p 28–31 (Sammlung Falckenberg) p 28–29 "Palabra
Tapada" by Santiago Sierra/VG Bild-Kunst, Bonn
2011, p 31 left "Captain Pamphile", p 31 middle
"ArtemisiaSogJod>Meechwimper lummerig", 2000
by John Bock, p 31 right "Das goldene Skelett;
(Der Sektenmensch starb) Koma/Roulette", 2000
by Jonathan Meese/VG Bild-Kunst, Bonn 2011, all
photos by Egbert Haneke;
p 34–35 (apollo9) p 34 "Cassandras" by Friederike
& Frederik, p 35 left "Oknosi Tityona" by Mike Mac
Keldey, p 35 middle "Neutra" by Hans Hushan,
p 35 right "Knospen" by Muriel Zoe, all photos
courtesy of apollo9;

p 36–37 (Feinkunst Krüger) p 36 art by Thorsten
Passfeld, p 37 left art by Jim Avignon, p 37 middle
left art by Dennis Scholl & Patrick Farzar, p 37 middle
right art by Dieter Glasmacher/VG Bild-Kunst, Bonn
2011, p 37 right art by Thorsten Passfeld, all photos
courtesy of Feinkunst Krüger;
p 38–39 (heliumcowboy artspace) art by Jon Bur-
german/courtesy of heliumcowboy;
p 40–41 (Lumas) courtesy of Lumas;
p 42–43 (Robert Morat Galerie) art by Simon
Roberts/VG Bild-Kunst, Bonn 2011, all photos by db;
p 44–47 (Tinderbox) p 44–45 "Loaded" by Holger
Niehaus, p 46 left "rigorose Daemmerung" by Tho-
mas Straub, p 46 right and p 47 "tomorrowland" by
Marc Bijl and Silke Koch/VG Bild-Kunst, Bonn 2011;
p 48–51 (Jenisch Haus) all photos courtesy of
Altonaer Museum;
p 52–53 (Sotheby's Hamburg) all photos by db;
p 54–55 (Museum für Kunst und Gewerbe) all
photos by db;
p 56–59 (Beatlemania Hamburg) all photos courtesy
of Beatlemania;
p 60–61 (Galerie auf Halb Acht) p 60 art by Rebelzer,
p 61 middle left art by Andreas Klammt, p 61 middle
right art by RuvV, all photos by Marc Rosswurm;
p 62–63 (Harrys Hamburger Hafenbasar) all pho-
tos by db;
p 64–65 (Vicious Gallery) photographical art by
Rüdiger Glatz, objects by Stefan Strumbel, all photos
by Rüdiger Glatz

ARCHITECTURE

p 68–71 (Dockland) all photos by db;

p 74–75 (Chilehaus) all photos by db;

p 76–77 (Haus im Haus) all photos by Hans Juergen Landes;

p 78–79 (Sprinkenhof) p 79 right by Andreas Vallbracht, all others by Leo Seidel; p 80–83 (Steckelhörn 11) all photos by David Franck/www.davidfranck.de;

p 84–87 (Speicherstadt) p 84–85 by db, p 87 left and middle by ELBE&FLUT/Thomas Hampe, all others by jt;

p 88–91 (HafenCity) all photos by db;

p 92–93 (Am Kaiserkai 56) p 92 and 93 right by Anke Muellerklein, all others by db;

p 94–95 (Elbphilharmonie Hamburg) all images courtesy of Herzog & de Meuron; p 96–97 (Marco Polo Tower) all photos by Roland Halbe;

p 98–101 (Unilever-Haus) all photos by Adam Mørk;

p 102–103 (Süd-Carré) all photos by db;

p 104–107 (Ehemaliges Hauptquartier Rickmers Reederei) all photos by Klaus Frahm/Richard Meier & Partners Architects;

p 108–109 (Empire Riverside Hotel) p 108 by Oliver Heinemann, p 109 left and right by Andrea Flak, p 109 middle by Michael Zapf;

p 110–111 (Tanzende Türme) all images by Strabag/www.datenland.de;

DESIGN

p 114–117 (Sofitel Hamburg Alter Wall) all photos courtesy of Sofitel;

p 118–119 (Das kleine Schwarze) all photos by Ralph Baiker;

p 120–123 (25hours Hotel HafenCity) all photos courtesy of 25hours Hotel HafenCity;

p 124–127 (SIDE) all photos courtesy of SIDE Hamburg;

p 128–129 (Superbude Hotel & Hostel & Lounge) p 128 and 129 left by db, all others courtesy of Hotel Superbude, Hamburg;

p 130–131 (The George) all photos by db;

p 132–133 (Das Ferienhäuschen) all photos by Kai Muellenhoff;

p 135–137 (east) all photos courtesy of east Hamburg;

p 138–139 (Mövenpick Hotel Hamburg) all photos courtesy of Mövenpick Hotels and Resorts;

p 140–143 (moondoo) all photos by db;

p 144–145 (Neidklub) all photos by Paul Ripke;

p 146–147 (Gorilla Grill) all photos by db;

p 148–151 (ONO by Steffen Henssler) all photos courtesy of ONO;

p 152–153 (Die Bank) all photos by Carsten Brügmann;

p 154–155 (River Kasematten) all photos by jt;

p 156–157 (stilwerk) p 156 courtesy of stilwerk, all others by db;

p 158–159 (Perle) all photos courtesy of Perle;

p 160–163 (Galeria GUDBERG) courtesy of Galeria GUDBERG;

p 164–165 (MAYGREEN) all photos courtesy of MAYGREEN;

p 166–167 (Stefan Eckert) all photos by db;

p 170–171 (Boutique Bizarre) all photos by Thorsten Hümpel;

p 172–175 (Wohnkultur 66) all photos courtesy of Wohnkultur 66;

p 176–177 (Die Wäscherei) all photos by Roland Bauer

COOL CITIES

Pocket-size Book
www.cool-cities.com

ISBN 978-3-8327-9490-3

ISBN 978-3-8327-9495-8

ISBN 978-3-8327-9484-2

ISBN 978-3-8327-9497-2

ISBN 978-3-8327-9595-5

ISBN 978-3-8327-9488-0

ISBN 978-3-8327-9496-5

ISBN 978-3-8327-9493-4

ISBN 978-3-8327-9489-7

ISBN 978-3-8327-9491-0

ART ARCHITECTURE DESIGN

Pocket-size Book
www.aadguide.com

ISBN 978-3-8327-9435-4

ISBN 978-3-8327-9433-0

ISBN 978-3-8327-9463-7

ISBN 978-3-8327-9464-4

ISBN 978-3-8327-9501-6

ISBN 978-3-8327-9465-1

ISBN 978-3-8327-9502-3

ISBN 978-3-8327-9499-6

ISBN 978-3-8327-9434-7

COOL CITIES +

A NEW GENERATION
of multimedia lifestyle travel guides featuring the hippest, most fashionable hotels, shops, dining spots, galleries, and more for cosmopolitan travelers.

VISUAL
Discover the city with tons of brilliant photos and videos.

APP FEATURES
Search by categories, districts, or geolocator; get directions or create your own tour.

COPENHAGEN
BARCELONA
SHANGHAI
TOKYO
SINGAPORE
BEIJING
VIENNA
PARIS
SYDNEY
HONG KONG
MUNICH
ZURICH
NEW YORK
SAO PAULO
AMSTERDAM
MIAMI
FRANKFURT
HAMBURG
LONDON
ROME
EMIRATES
CHICAGO
MILAN
BERLIN

© 2011 Idea & concept by Martin Nicholas Kunz, Lizzy Courage Berlin
Selected, edited, and produced by Sabine von Wegen
Texts by Sabine von Wegen
Editorial coordination: Miriam Bischoff
Executive Photo Editor: David Burghardt, Photo Editor: Maren Haupt
Copy Editor: Dr. Simone Bischoff
Art Director: Lizzy Courage Berlin
Design Assistant: Peter Krämer
Imaging and pre-press production: TRIDIX, Berlin
Translation: finetext, Hamburg (Caspar Zoeftig, Linda L. Gaus)

© 2011 teNeues Verlag GmbH + Co. KG, Kempen

teNeues Verlag GmbH + Co. KG
Am Selder 37, 47906 Kempen // Germany
Tel.: +49 (0)2152 916-0, Fax: +49 (0)2152 916-111
e-mail: books@teneues.de

Press department: Andrea Rehn
Tel.: +49 (0)2152 916-202 // e-mail: arehn@teneues.de

teNeues Digital Media GmbH
Kohlfurter Straße 41–43, 10999 Berlin // Germany
Tel.: +49 (0)30 700 77 65-0

teNeues Publishing Company
7 West 18th Street, New York, NY 10011 // USA
Tel.: +1 212 627 9090, Fax: +1 212 627 9511

teNeues Publishing UK Ltd.
21 Marlowe Court, Lymer Avenue, London SE19 1LP // UK
Tel.: +44 (0)20 8670 7522, Fax: +44 (0)20 8670 7523

teNeues France S.A.R.L.
39, rue des Billets, 18250 Henrichemont // France
Tel.: +33 (0)2 4826 9348, Fax: +33 (0)1 7072 3482

www.teneues.com

While we strive for utmost precision in every detail, we cannot be held
responsible for any inaccuracies, nor for any subsequent loss or damage arising.
Bibliographic information published by the Deutsche Nationalbibliothek.
The Deutsche Nationalbibliothek lists this publication in the
Deutsche Nationalbibliografie; detailed bibliographic data are
available in the Internet at http://dnb.d-nb.de.

v 1.0
Printed in the Czech Republic
ISBN: 978-3-8327-9502-3

BEI UNS BEKOMMT DER KUNDE ALLES AUS EINER HAND. UND ZWAR AUS DER, DIE ER ZU BEGINN UNSERER PARTNERSCHAFT GESCHÜTTELT HAT.

Wir verstehen uns nicht nur als **unabhängige Vermögensverwaltung**, sondern leben dieses Prinzip. Intransparente Produkte lehnen wir strikt ab. Vertrauensvolle Mitarbeiter der VM Vermögens-Management GmbH finden Sie seit 1986 an Standorten wie Düsseldorf, Dortmund, München und Stuttgart. www.vmgruppe.de

Ein Unternehmen der August von Finck Gruppe

VermögensManufaktur

vm.